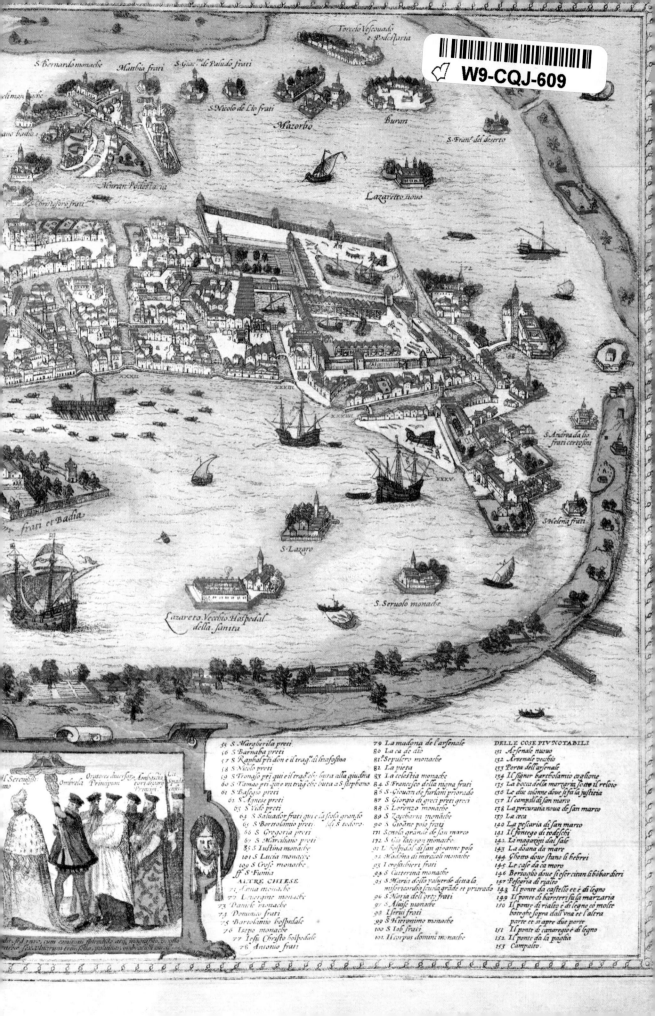

IN THE SPIRIT OF

VENICE

© 2005 Assouline Publishing
3 Park Avenue, 27th Floor
New York, NY 10016 USA
Tel: 212-989-6769 Fax: 212-647-0005
www.assouline.com
ISBN: 2 84323 663 0
10 9 8 7 6 5 4 3
Printed in China.

ALEXIS GREGORY

IN THE SPIRIT OF

VENICE

ASSOULINE

Coat of arms of the *serenissima* republic of Saint Marks divided into sixteen districts.

Contents

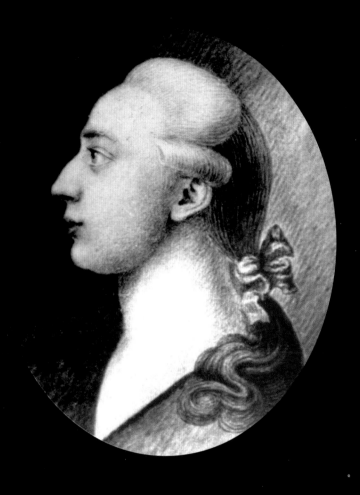

Above: Portrait of Giacomo Casanova, woodcut, 1875.
Opposite: A winter morning in Venice.

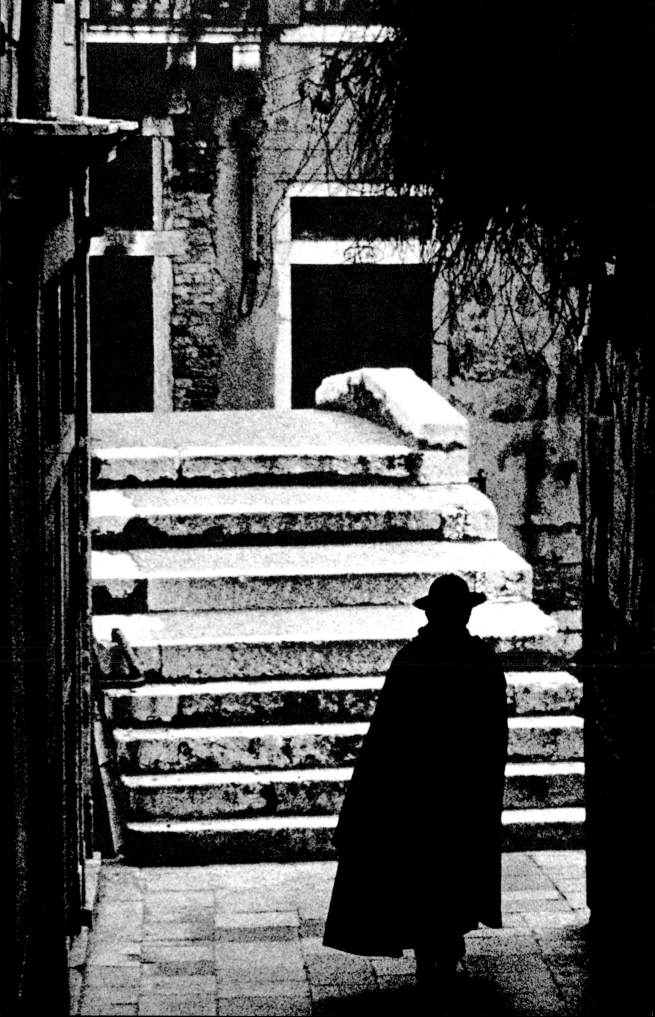

Introduction

Venice is one of the most legendary places in Europe. In today's world of mass tourism and organized travel, most people are not given the time to visit or enjoy it properly. It is often added to a tour of other Italian cities, people see the obvious sights in varying degrees of comfort, take a trip on their own gondola if they can afford it, or go in a group of gondolas accompanied by a shouting singer, which is the very antithesis of the deadly silence and contemplation that a trip on these funereal barks is supposed to elicit. Silence and contemplation are the true luxuries of this most beautiful and strange of all places, and can be found only after dark, when the day trippers have left, or in the cold of winter when tourists are in warm climates or skiing and the rest of the world is at home working or simply leading their lives. Visitors to Venice today are assailed by the noise of motorboats, the shuffle of feet along the ancient pavements, the smell of mozzarella from a pizzeria open to the street, the complaints and wails of exhausted children, the ugliness of vulgar souvenirs in small shops. From June to September, the city is often hot and humid and can be visited without suffering only in the early morning or late afternoon.

Notwithstanding, everyone's senses are aroused by the sheer beauty that surrounds them, by the bright light and water, the beautiful places they visit, the masterpieces they admire. One would have to be blind or braindead not to be dazzled by the beauty and sense of history of this most original of places, and such is Venice's renown that people who can't afford anything else will gladly sit in a bus all night to come from a destination in Central Europe, walk around Venice all day consuming only the modest fare they have brought with them, and then spend another night sitting up in their crowded bus returning home. Venetians complain that they only crowd the city and add to its accumulation of trash, but the reality is that their city is a world treasure that belongs to everybody, rich and poor alike.

In a way, there is a certain equilibrium. While the poor pay little for the experience, rich visitors are glad to spend thousands of euros, dollars, or yen per day on luxury hotels, personally guided visits, water taxis with a $65 minimum, light lunches at $100 per person, and $15 espressos on the Piazza. Their credit cards are in constant use in the luxury shops situated in the center of the city, they will pay $50 to use the Cipriani pool for a single swim, and many organize two-or-three-day parties to celebrate a special occasion, happenings that cost $1,000,000 or more. Then there is a whole way of life that is followed by distinguished, rich and famous people who buy or rent apartments and palaces here. These comprise a large contingent of Milanese industrialists and bankers who use Venice for their weekends and holidays, British lords, Elton John, American millionaires, French and Italian designers like Hubert de Givenchy and Beppe Modenese, and many distinguished intellectuals, writers, and painters. The epitome of this cosmopolitan mix is Pierre Rosenberg, the now retired director of the Louvre, and his cultivated wife, née Béatrice de Rothschild, who have rented a floor in the Brandolini palace where they live, study, and write all year long. All these people could be anywhere in the world, but they have chosen Venice, a very private Venice that they share with the aristocratic descendants of the great patrician families, many of whom still live in all or part of their family palaces.

These people follow in the footsteps of the eccentric and rich Marchesa Casati, Peggy Guggenheim, and Winnaretta Singer, to whom I have devoted chapters in this book. They also follow in the footsteps of Arturo Toscanini, Igor Stravinsky, and Sergei de Diaghilev who make brief appearances here. Rich and poor, intellectuals and hedonists, the highly knowledgeable and the quite ignorant, all share the Venetian heritage, the city's unique setting, the beauty of the Italian sky and light. The purpose of this book is to convey many different settings, people, and periods that make up a particularly rich patchwork.

Alexis Gregory. New York, December 2004

Acqua Alta

Water is the life force of Venice. It protected the first settlers on the marshes from marauding barbarians, and permitted early Venetians to live safely on the small and independent islands, with only ships to connect them with the world. The Riva Alta, also known as the Rialto, is the main island of what was to become Venice. It consists of a large land mass and surrounding islands, some of which are connected to it by bridges; the smaller ones became part of the city, and the more distant ones part of the lagoon. Venice's direct access to the Adriatic allowed ships to bring in and export the goods whose trade made the republic rich. Finally, its waters, and their reflected light, influenced the colors mixed in the palettes of the city's great painters and infused their work with a special luminescence.

A city built on water makes everybody feel different. There is no dust, no noise, no roads or traffic. The sun reflects the sparkling water on multihued palaces, lighting up their facades. Surrounded by water, its inhabitants feel they can behave freely, even sinfully, and go unnoticed. And visitors can enjoy Venice as a resort, as well as an active city. It was the poet Lord Byron who plunged into the Grand Canal every day to take his exercise after a day's work. Venice's waters cool the city on some summer days, but it can be as hot and swampy as Panama on others. Beautiful fireworks multiply on the water's mirror-like surface during the many festivities that Venetians adore organizing. Water is the miracle of this strange and beautiful world, and yet it is ever threatening to destroy what it inspired.

Other than an extended rainy season, acqua alta, or high water, is the only malevolent form that water takes in Venice. The brackish waters of the Adriatic arrive and depart through a narrow channel, and at high tide the water surges

An acqua alta in the Piazza San Marco.

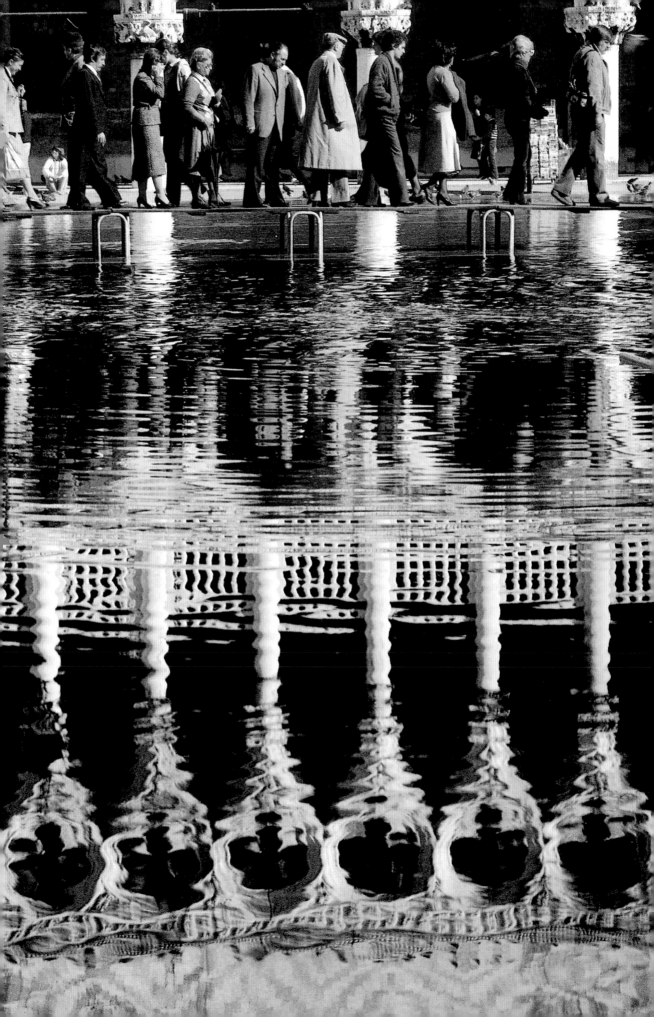

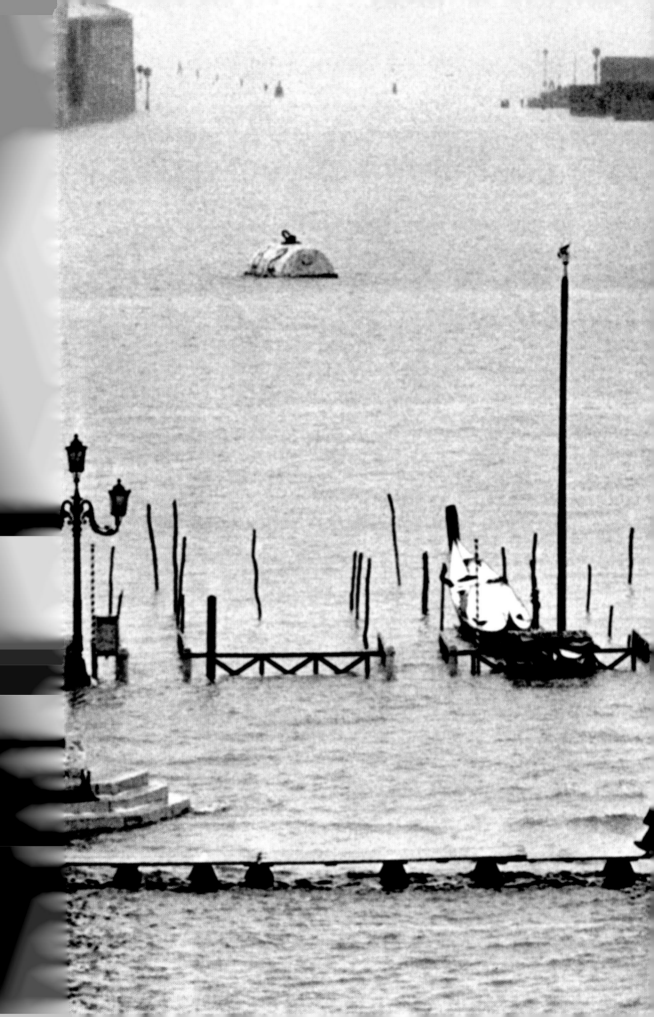

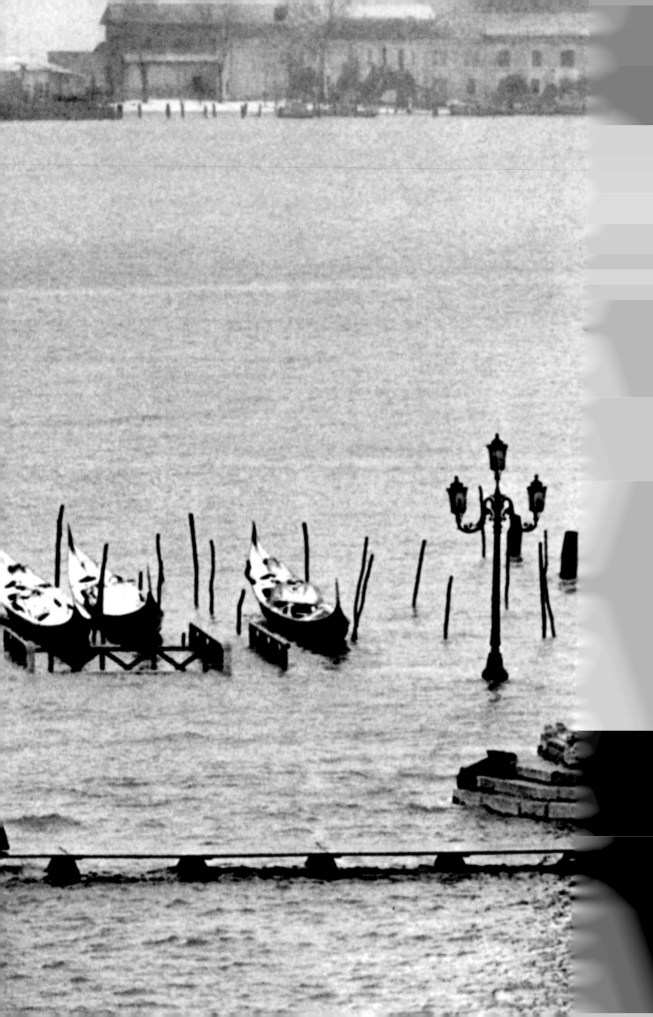

through that channel toward the city with no diversion for its force. It can rise inches, feet, and occasionally yards above its natural level, flooding squares, streets, and the ground floors of houses before returning to the open sea. The Venetians, in fact, generally left the ground floor of their palaces and homes empty so that the then rare acque altae would not damage them. Nowadays this is no longer always true, particularly of commercial establishments like shops, hotel lobbies, and restaurants, whose staff have to rush around saving everything from destruction when an acqua alta changes the city.

The approach of an acqua alta is heralded by the placing of raised platforms in the streets for pedestrians to walk on and stay dry when water fills the city. Gondolas and other small vessels may soon navigate through the Piazza San Marco, and tourists savor every detail of this odd happening. While vistors may relish in the adventure of flooded hotel lobbies and squares, Venetians are fearful, ill at ease, wondering if this time their treasures will be destroyed forever. Will the Titians and Tintorettos float down the Grand Canal and be lost to the world? Will frescoes turn to mush? Will the books and manuscripts that tell the history of a once mighty empire turn to pulp?

The disaster that always springs to mind when discussing the fragility of Venice is the terrible flood in Florence in the 1960s, when hundreds of thousands of historic books and manuscripts were destroyed, priceless paintings damaged, and a film of scum rose up to the first floor of buildings in the historic part of the city. At the beginning of the century, there were an average of ten acque alti per year; now that figure is often six times as large, partially due to global warming. It is said that Venice sunk nine inches over the past one hundred years. There have been many plans to hold back the waters, the most recent of which is Project Moses, which calls for inflatable rubber floodgates on the floor of the channel that can be instantly filled with air to rise and act like dams. But the plan has been held back by environmentalists and ecologists, who are more concerned with the extinction of a few species of shrimp and fish than the disappearance of a civilization. Also threatening the city are plans to build an underwater subway, turn the Grand Canal into a highway, and even erect office buildings in the heart of the city. Fortunately, good sense has thus far prevailed and water remains at the epicenter of Venetian consciousness and life.

Preceding double-page: The Piazzetta San Marco underwater.

Grand Canal

There is so much to be seen in Venice, yet nothing surpasses an inexpensive trip on the Grand Canal in a vaporetto, the local means of transport. Packed with sweaty tourists during a heat wave, empty on a gray winter's day, or peaceful at sunset or in the dark of night, the fascination of riding along the Grand Canal never ends. Even after hundreds of trips, the ride remains a dazzling experience. The Grand Canal is an urban miracle—as is the entire city—and would be the apotheosis of city planners if it had been planned, which, of course, it was not. Admittedly, there is a depressing start: a hideous concrete garage for thousands of cars that stands behind an asphalt roadway, shortly followed by a neofascist railroad station that is a disproportionate, rectangular, marble-sheathed coffin. Everyone who lives in Venice is conscious of the hawk-like supervision of the Soprintendenza dei Belli Arti, who today won't allow a window to be changed, an awning put up, or a bathroom remodeled without their permission, and certainly would have never allowed these monstrosities.

The garage and the station are, of course, egregious errors, and there are a few other glaring mistakes—most of an earlier vintage and thus less disturbing—as you go all the way to the Piazza San Marco, which is the highlight of the trip. The canal, referred to by Venetians as the Canalazzo, is remarkably homogenous and cohesive, as if every generation of architects and builders since the beginning of the city had tried to make this two-and-a-half-mile stretch of palaces, churches, and civic buildings fit together. One passes Byzantine, Gothic, Renaissance, and Baroque buildings, tiny palaces, and enormous churches. Some buildings are set back with large gardens; others are seemingly planted in the water. There are highly elaborate, sculpted facades,

The Grand Canal.

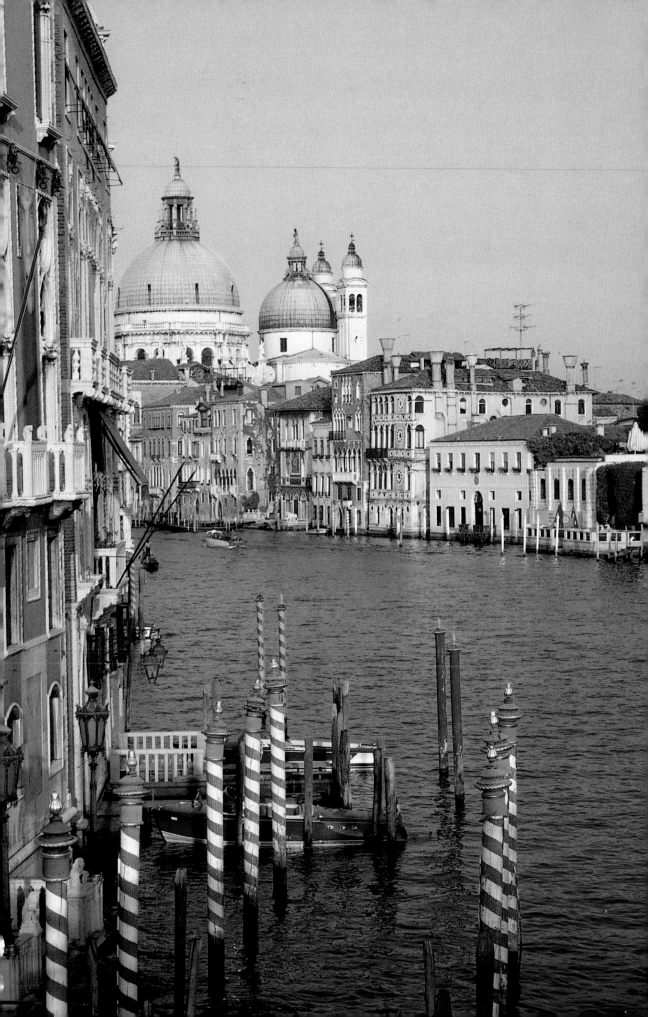

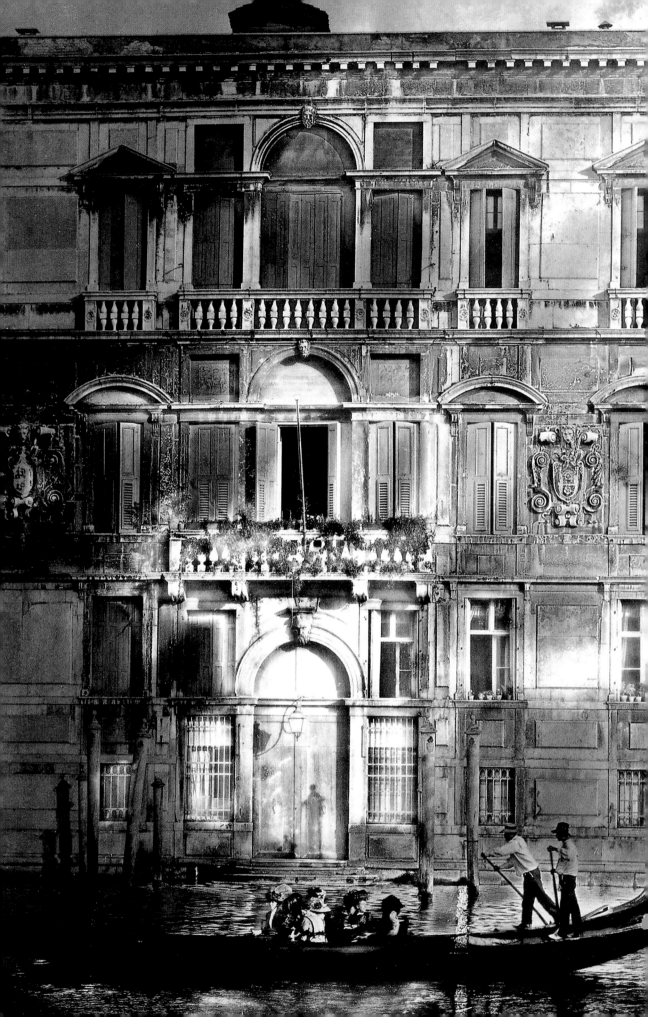

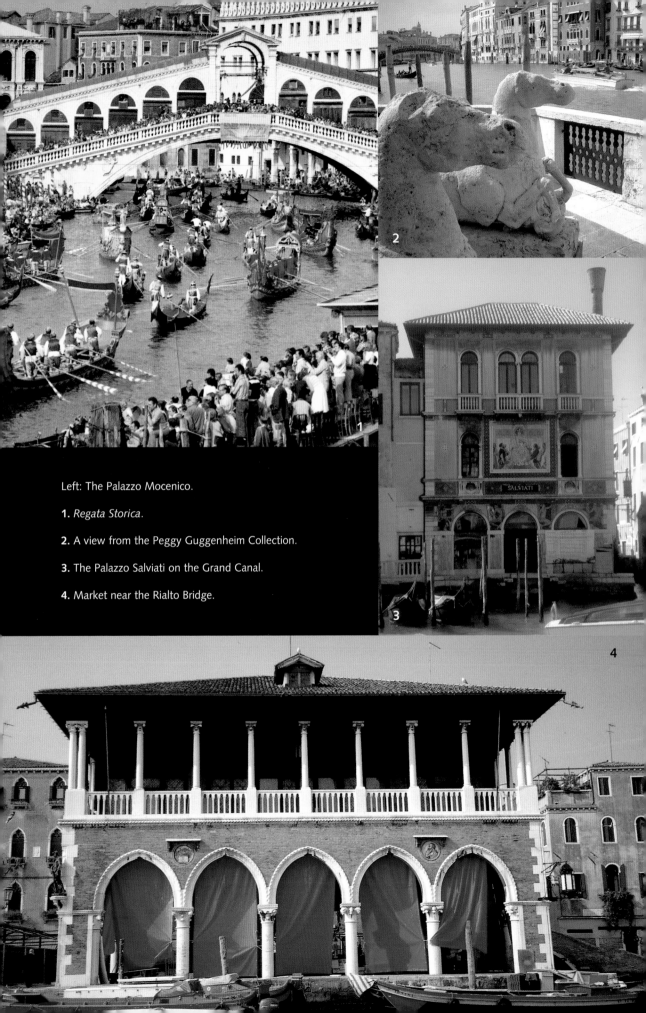

Left: The Palazzo Mocenico.

1. *Regata Storica*.

2. A view from the Peggy Guggenheim Collection.

3. The Palazzo Salviati on the Grand Canal.

4. Market near the Rialto Bridge.

as well as solid walls with nothing more than arched or ogival windows. And every pastel shade appears, from peach to pistachio.

Many buildings were altered to fit a new style—an originally Gothic palace could have received Renaissance ornamentation, for example. Some palaces were knocked down and rebuilt extravagantly, whereas others were seriously damaged by their owners. The vedute paintings of the Grand Canal from more than two hundred years ago, by Canaletto and Guardi, indicate that the structures then were quite different than they are today, although no less cohesive. The major monuments—the Rialto bridge, the Salute, the Doges' Palace, the Fondaco dei Tedeschi, the Dogana—are in the same place and unchanged, but many buildings have disappeared. People were pretty much allowed to build what they wanted, but clearly there was a collective sensibility that stood in for today's omnipresent Soprintendenza.

The Canalazzo was, in fact, once a river that entered the lagoon from the north and made its way to the sea. Its major twists and turns have remained the same for centuries. It was blocked on one end and the tides now run to and from the ocean, cleaning out the Grand Canal, as well as its smaller passages, by bringing in and out massive amounts of water every day. The Grand Canal is the dominant feature of Venice's urban program. Large and weighty buildings could be erected directly on the marshy islands of the city by sinking wood piles in the mud onto which wooden planks were laid to make a foundation. The popular conception of Venice as a surrealist, shaky city built in the water on top of hundreds of thousands of piles is, therefore, partly a fiction but actually still a fact. What is not a fiction is that Venice is in greater peril because of its exposure to the vagaries of the open ocean and tides, which are far stronger than those of the river that once flowed through it.

Venetians were, of course, merchant mariners and traders, and these activities were the basis of their wealth. Their palaces were used in part as offices and warehouses, and the ground floors often served as loading platforms and storage space for their goods. Ships from the Orient would sail directly up the Canalazzo to the palaces to load or unload their precious cargoes. The ground floor, the *androne*, is therefore seldom decorated. The merchandise could be moved upstairs in case of a flood and no harm was done. Public warehouses and

docks, of course, were eventually built, but the *androne* remained unadorned as it was vulnerable during high tides. The second floor of the palace, the *piano nobile*, was used by these rich traders to display their vast wealth and power in lavish reception rooms. Here are the frescoed and stuccoed ceilings and walls, the silks, velvets, and taffetas decorating elaborately carved furniture, and the windows and balconies overlooking the Grand Canal from which the nobility would watch processions for visiting ambassadors and dignitaries.

During the heyday of the republic, there were processions on the Grand Canal all the time, with sumptuous multicolored and gilded ships that reflected the wealth and might of the great Venetian patrician families. The crews were dressed in the family colors, the doges in red ceremonial robes, and the sounds of trumpeters and drummers rang across the Grand Canal. Anything was an excuse for such a parade, which often included the *Bucentoro*, the red and gold ship of state. Today, these processions are evoked in the Regata Storica that precedes a series of races between different size gondolas from the various islands of the lagoon in early September, one of the big events on the Venetian social calendar.

A long gallery, stretching the entire width of the palace, was traditional and often decorated with a historical or allegorical program glorifying the owners. The gallery led to large, high-ceilinged salons with mosaic-like stucco floors or patterned marble parquet, where banquets and masked balls took place. The upper floors of these buildings contained palatial salons and bedrooms, and were used for everyday life. Also tucked away in many of the palaces were small theaters or chapels for private devotion.

Vaporetto riders are always intrigued to know who owns each palace and what goes on inside these Grand Canal structures that they pass on their journeys. Many have been divided into apartments, some are offices, others foundations. Some have become government buildings, banks, showrooms, and naturally, hotels whose signage gives them away. But many are still private and inaccessible. In the evening, tourists in the vaporetti look up into these well-lit, luxurious living rooms where beautifully dressed people are drinking, talking, and leaning on the velvet padding of the balconies' railings, and wish they were up there, sharing the secrets of Venice.

Lagoon

During tourist season, particularly on the hot days of summer, Venice becomes particularly crowded and uncomfortable. Tourists pack into the vaporetti like sardines, garbage cans overflow, crowds shuffle through the streets, and pigeons on the Piazza are so overfed that they seem too stuffed to fly away from the sandaled feet that wade through them. Shirts come off, brows are mopped, children dribble ice cream over their chins, and there are few possible escapes. For the rich, there are air-conditioned hotel suites and chaise longues around the Cipriani pool, and for everyone else there is the lagoon.

The lagoon, consisting of 212 square miles of brackish water, recalls the early days of Venice. A cruise through its many islands reminds us how the early Venetians lived, farming the produce that are staples in their diet like corn, which is used for polenta; small, succulent artichokes; and beans for *pasta fagioli.*

The island of San Giorgio Maggiore.

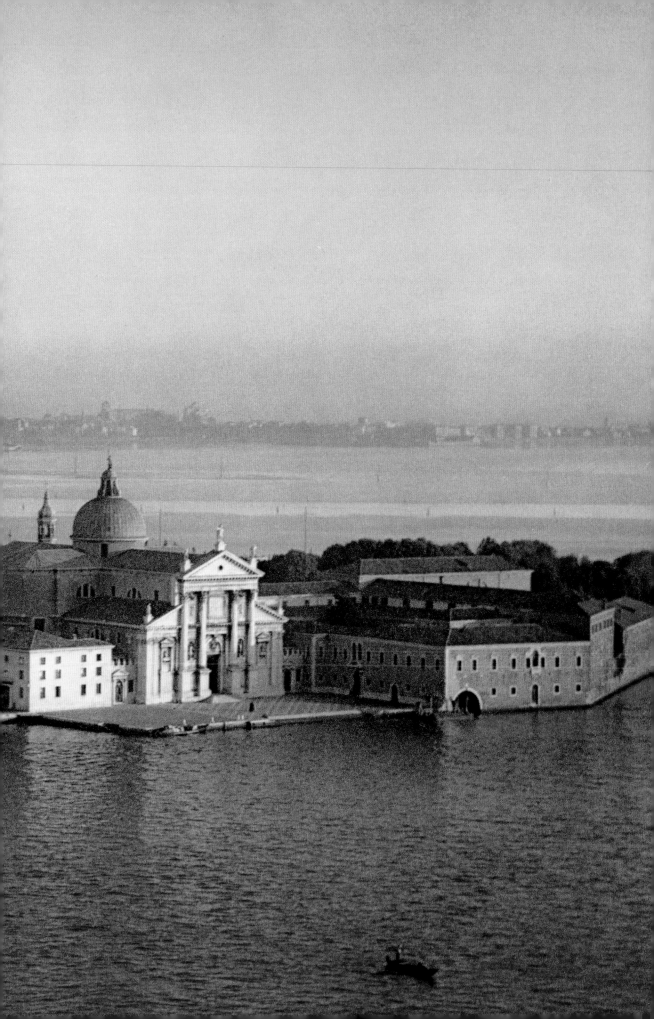

Above: Portrait of Thomas Mann at the beginning of the twentieth century.
Below: The beaches of the Lido on the set of *Death in Venice* by Luchino Visconti (1971).

Below: The Excelsior Hotel in *Death in Venice* by Luchino Visconti.
Right: Marisa Berenson in the same film.

The multiple shades of green in the water and vegetation on the lagoon, as well as the wind breezing through fields and trees, remind us that we have left the city and arrived in the countryside. Venetians cruise along in bathing suits in their small craft, sometimes taking a dip in the brackish water. And athletes row their gondolas, a nomenclature Venetians apply to all sorts of boats that are poled through the water, keeping in shape for the many races between island teams, the most important being the *Regata Storica* that takes place on the Grand Canal in early September. Stocky men in loose undershirts, their ample wives, and half-naked children sit on the narrow shore enjoying picnics; scenes that would have inspired Henri Cartier-Bresson or Renoir. There is a lot of traffic between the islands of the lagoon, and many Venetians commute to and from their jobs in Venice during the week. To a certain degree, the islands of the lagoon are bedroom communities; with mechanized farming and limited tourism, there are few jobs. In fact, the only industry on the lagoon is fishing, glassblowing on the island of Murano, knitting lace on Burano, and tourism on the Lido.

The Lido is a long strip of land that acts as a sort of breakwater to the open Adriatic, protecting the islands of the lagoon. It was in the lagoon that Saint Mark, the patron saint of Venice, was rescued from a shipwreck while on a mission to found the diocese of Aquileia. Today the Lido is filled with cars, noisy children, family hotels, pensions, pizza parlors, and inexpensive restaurants. Like all Adriatic resorts, the beaches are body-to-body in August and totally empty by October. Exemplary of the grandeur of the past are the Moorish Hotel Excelsior Lido and the international-style Grand Hotel des Bains, where Sergei de Diaghilev, Coco Chanel, Vaslav Nijinsky, and Thomas Mann's von Aeschenbach once camped out. The Excelsior, opened in 1908, was once the epitome of the grand hotel with its *thés dansants* and costume parties, its sumptuous dining room filled every night with celebrities in black tie, pretty flapper girls, gigolos, and loud Americans on holiday. Today, it is simply a good hotel on the beach.

Years ago, international society lounged on the Lido during August's hot days and only ventured into Venice in the late afternoon or evening, after the weather cooled. The highlight of each day was lunch in or around the tents of the Excelsior beach, where all the grandees of Venice held open house,

enjoying picnic lunches cooked by their chefs and served by waiters in the family livery. The hierarchy of tents was as fixed as protocol at the Italian court. Life returned to the Grand Canal and its palaces only during Regatta Week in early September, when everyone palace-hopped, drank champagne, and talked about where they had summered. Wonderful photographs have preserved this elegant period on the Lido, like the image of Serge Lifar in his swimming singlet hoisting into the air a great lady dressed in black lace, or Charlie Chaplin in his white flannels leaning on a cane.

Not as popular, but far more interesting than the Lido, are the three islands north of the lagoon: Burano, Murano, and Torcello. Connected by vaporetti, all three can be taken in during a single day, though it is far more luxurious to take your own boat and not obsess over schedules. Upon entering the lagoon, the first event is the cemetery of San Michele, where it's not uncommon to pass a slow and stately funeral procession led by a large black coffin-bearing gondola with masses of flowers, elegant attendants and gondoliers in silver-trimmed black livery. They too are wending their way to a chapel inside a pink necropolis where silent monks busily float around, organizing the last rites of Venetians who reserve their spaces far in advance.

In the cemetery are large, elaborate tombs and memorials including those of Ezra Pound, Sergei de Diaghilev, Igor Stravinsky, and many other famous artists. It can be said that they are among the few who have hung in, as the remains of ordinary mortals, after a dozen or so years, are disinterred and carted off to a distant island, where they are dumped into a common grave.

It is a mere hop from this island of the dead to the colorful shores of Murano and its legendary glass factories. Though most have small showrooms in Venice itself, it's much more fun to choose your own—or special order— handblown Venetian glass. The displays are larger than those in town, and visitors are always fascinated by sweaty workmen in T-shirts, their red cheeks puffing out as they blow air through steel pipes into a molten blob of glass that they manuever like fresh toffee into an endless variety of shapes. Glass has been a major Venetian industry since the twelfth century; it came of age during the Renaissance with the master glassmaker Angelo Barovier and his family. It was Barovier who first produced clear glass in simple shapes that

were then gilded and painted. His bowls featuring mythological figures, especially those in deep blue glass, are among the most treasured and rarest of Renaissance *objets d'art*.

Throughout history, Venetian glass has been widely exported. The most important and elaborate pieces were once treasured by European courts, just as they are now adored by Arab sheiks and flashy new millionaires. The glass-makers had their own exclusive guild and could literally get away with murder. They were virtual prisoners in Venice and the Veneto, since other glassmakers all over Europe were eager to acquire their skills and secrets and crack into their monopoly. Though emigration was punishable by death, by the eighteenth century several artisans were tempted by exorbitant offers and escaped. Imitations, known as *Façon de Venise*, were produced principally in Holland (initially by the Venetian deserters), and once the secrets became public knowledge, the Venetian glass industry declined. Nonetheless, it remained important, particularly since the skilled Venetian glassmakers carefully followed fashion.

After the initial simple beakers and pedimented bowls of the Renaissance, baroque glassmakers produced glorious vessels from multicolored filigree batons that were melted together and twisted into undulating shapes with geometric or linear patterns. Gold dust was fused into the glass, which was then blown into the shape of a drinking vessel and placed onto an animated dolphin or sea monster, lending much opulence. Most spectacular were the enormous chandeliers that embellished the great salons of the *piani nobili* of Venetian palaces; these chandeliers were quite literally giant bouquets of multicolored flowers. There was lovely art nouveau glass in the nineteenth century, and great masters such as Salviati and Venini took their place in the history of the decorative arts in the twentieth century. Today we have artisans like Seguso and Scarpa, who create sculptural objects of museum quality. Alongside these serious works is a massive industrial production of *souvenirs de voyage* junk: small gondolas and gondoliers, flying monkeys, gaudy Santa Clauses, hideous mirrors, lumpy bright green ashtrays, and kitchy, candle-bearing blackamoors. But do keep an eye out for the small, colorful fish that can be put in a guest's fingerbowl and are truly chic.

A glass from Murano.

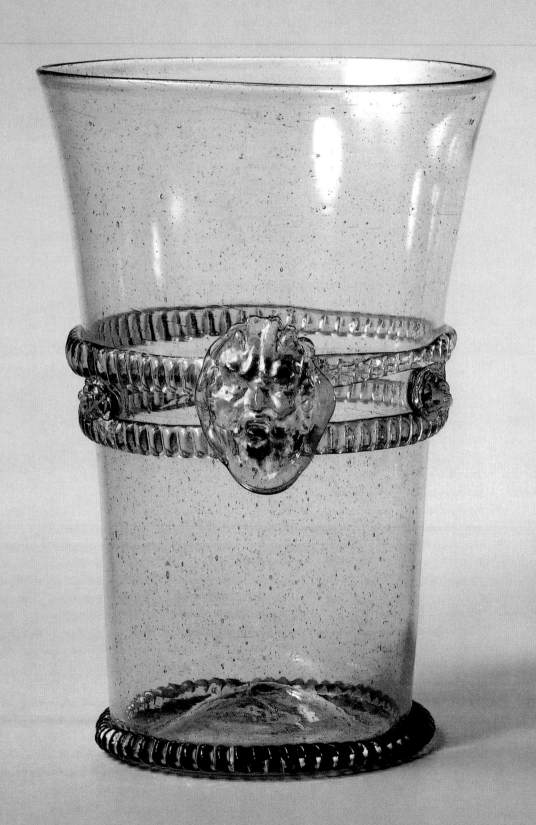

And make sure to pass by the nearby Museo Vetrario before visiting Santa Maria e Donato, a three-aisle, well-lit Byzantine church that once contained relics of Saint Donatus that were brought from Cephalonia in Greece. It has a splendid bell tower and a wonderful, restored facade made up of arches supported by Byzantine columns. Built around 700 and reconstructed in 1141, the church's distinguishing feature is the rich, geometric mosaic floor, similar to the one in San Marco, with peacocks and other fowl pecking at a bowl of grain.

The finest Byzantine church in the lagoon is on Torcello, where Saint Francis supposedly was shipwrecked. Torcello was also known as New Altinum, after Attila the Hun chased out the people from ancient Altinum, once one of the most important cities in northeastern Italy. And in 638, the bishop of Altinum transferred his cathedral and its relics to Torcello, which subsequently became the most inhabited city in the lagoon. The church was first rebuilt in 864 and completed in 1008 by Orso Orseolo; most of what remains today is from the reconstruction. There are very few visitors to the church and its setting is bucolic. This cathedral contains magnificent Byzantine mosaics, sculpture, and a splendid floor, into which is placed the marble tombstone of Paolo d'Altino, the bishop of Torcello. The nave is delineated by marble sheathed columns, with Corinthian capitals embellished by thorny acanthus leaves that support a row of rhythmic arches. It culminates in a splendid iconostasis made up of six thinner columns that hold up a series of effigies of the Virgin and saints, and frame four highly decorative, carved Byzantine reliefs of peacocks and lions. In the apse vault, the effigy of the Byzantine Hodegetria Virgin is set into a gold mosaic ground. The entire west wall is covered by eleventh and twelfth-century Venetian-Byzantine mosaics showing scenes of the Last Judgment, including the lustful burning in the fire of their passions, and rows of Aztec-like skulls whose eye sockets sprout snakes. These could serve as a warning to the greedy, who will now want to walk a few steps for a delicious and expensive lunch at the Locanda Cipriani, or the proud, who might be reminded that Torcello was very soon superceded by Venice, and its glory and people faded away.

Mussel farms in Venice.

Plague & Beauty

Venice was particularly susceptible to the plague, also known as the Black Death, which was introduced by rats who slipped off ships returning from filthy and disease-infested foreign ports. Once the rats disembarked, the fleas that happily nestled in their fur, gingerly hopped off their backs, finding new hosts among all classes of Venetian society. It took a while for the magistrates of Venice to agree that the disease was contagious, and finally, boats whose passengers and crew were infected with the plague were kept at sea for forty days, thus the origin of the term "quarantine." After quarantine, the likelihood of anybody being alive on board was slight indeed, but nonetheless, the fleas remained active on the shore.

The progress of the plague was inexorable and terrible to watch. It started with a raging fever that sought release through dreadful pustules that appeared all over the victim's body. The pain was unbearable, and death

A View of the Church of the Redentore (detail), Canaletto, oil on canvas, 18$^{2/5}$ x 30$^{1/5}$ ", Dover Street Gallery, London.

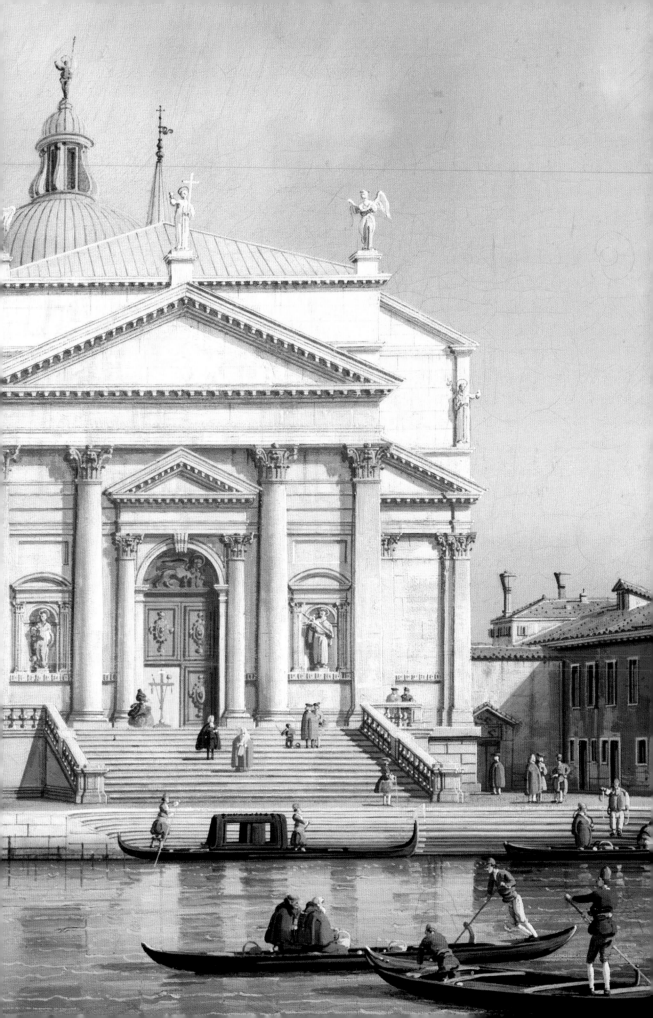

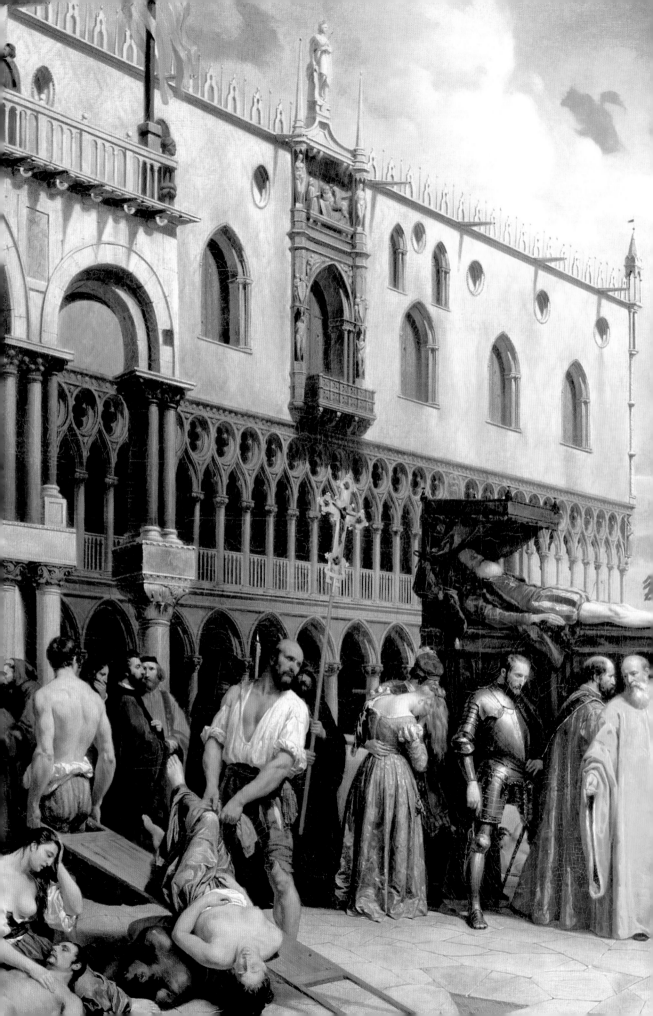

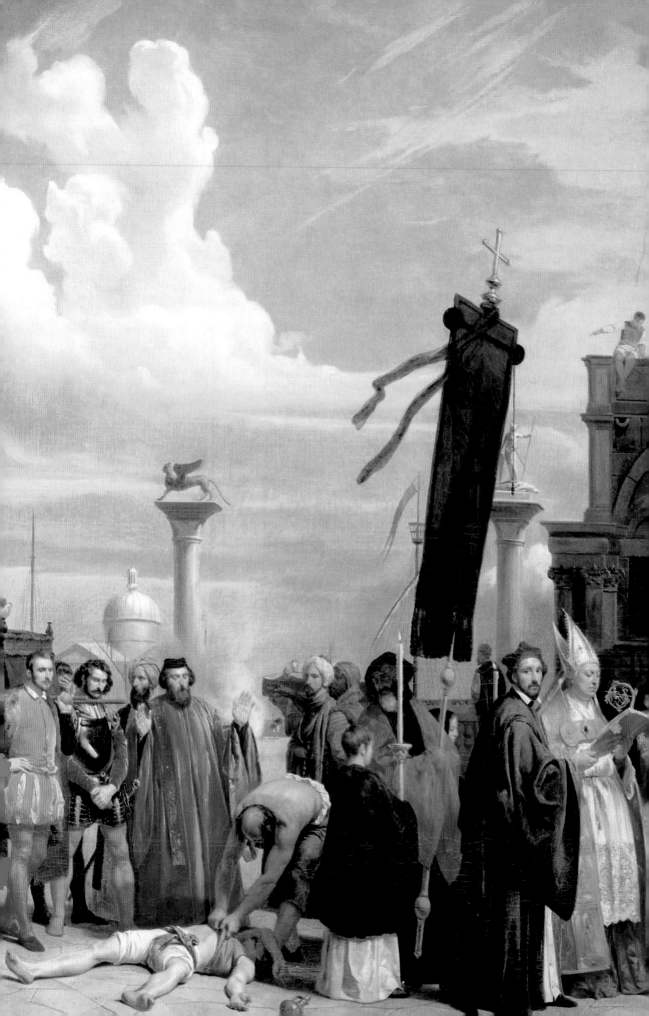

practically inevitable, all of which created widespread panic and terror, as well as the disintegration of law and bodies, turning the city into a pestilential hellhole and further spreading the disease. There was no cure until the plague had fed upon itself and a temporary immunity finally set in. The rats and fleas then carried the plague elsewhere, and the entire population of Europe was decimated. Thirty percent of Venetians died during three bouts with the plague, in 1348, 1575, and 1630. Only divine intercession seemed able to resolve the problem, particularly as all areas of the government seemed to be falling apart.

To celebrate the end of the plague of 1575, Andrea Palladio designed the Church of the Redeemer, Il Redentore, on the far bank of the Giudecca Canal, opposite the Fondamenta delle Zattere. The perfectly proportioned and symmetrical neoclassic facade, with its Corinthian columns, pilasters, and pediment, makes a major statement, particularly on the third Sunday in July, known as the feast of the Redentore, when boats are linked together between St. Mark's basin and the banks of the Giudecca Canal, and people come from all over the city to join a procession celebrating the end of the plague.

At sunset on the day of the Feast of the Redentore, anything that can navigate the waters gathers in the canal. The broad-bottomed boats that transport the likes of cement and grand pianos are stripped down, and narrow tables are set up for families and friends to feast on *sarde al saor* and other typical Venetian dishes while getting tipsy on inexpensive wine. Yachts join the crowd of boats, as do gondolas and ferries, and the municipality and the mayor send out brilliantly lit floats, pulled along by tugboats; these sometimes include orchestras for dancing. In the early part of the evening, carefree youngsters dive into the water to cool off, and at dusk navigation becomes inconceivable. The police seem particularly good-humored as they cruise around, attempting to keep a semblance of order. At dark, everybody cheers as brilliant fireworks fill the sky and magically light up the city's monuments. The celebration touches all elements of society, as did the calamitous disease. When the fireworks end, some of the ships quietly depart while others remain in the lagoon to watch the sunrise.

Preceding double-page: *The Last Rites of Titian, during the plague of 1576,* Alexandre Hesse, 1833, oil on canvas, 641$^{2/3}$ x 917$^{1/3}$ ", Louvre, Paris.

The building of the Redentore was, of course, not a permanent solution to the plague. The fittest survived, but the hardy rats fostered new strains, and the catastrophe returned fifty years later, claiming nearly 50,000 victims from July 1630 through October 1631. Terrified, the Venetians tried the usual remedies and prayed. The Senate decreed that if their prayers were answered, they would build a church of pomp and magnificence dedicated to the Virgin Mary, hence the Santa Maria della Salute (health or salvation).

While the Redentore is a perfect summation of neoclassicism, the Salute is a triumph of the Roman Barqoue, which Gian Lorenzo Bernini dominated in both sculpture and architecture. As was often the case in Venice, there was a competition: eleven architects submitted plans after 1,156,627 wooden piles were fixed in the mud to create a solid foundation. The criteria were that the entire interior should be instantly visible to a visitor; that it should be luminous, with light evenly distributed, that it shouldn't cost too much; and that it should make a *bella figura*. Baldassare Longhena, the 30-year-old son of a talented local stonecutter, won. In his proposal, Longhena wrote: "I have designed a church in a round form the result of a new invention, never before built in Venice... As it is dedicated to the Blessed Virgin, it came to me...to build it in the form of a crown to be dedicated to the Virgin." The church was only finished in 1687, five years after Longhena's death. It is the dominating landmark of the entire San Marco basin, and certainly among the most powerful monuments in Venice. To complement this magnificent building, there is an important sculptural program, starting with a statue of the Virgin Mary on the very top of the dome, carrying the staff of an admiral of the Venetian fleet. She appears again on the sculpted high altar of Juste Le Court carrying out the request of the republic to chase away the plague.

The plan was indeed revolutionary, and the brilliant facade, with its imposing Istrian marble flights of stairs, profuse statuary, and forest of Corinthian columns and pilasters, is certainly the most dramatic in the city. Like the Taj Mahal, the Salute changes color throughout the day and night, and those who breakfast on the terrace of such grand hotels as the Monaco, the Regina, or the Europe can consider themselves the luckiest people in the world to start their day on such a high note.

San Marco

At the very heart of Venice is the Piazza San Marco, the most beautiful square in the world. While there are many *campi* (small squares, or literally fields), this is the city's only piazza, which Napoleon rightly called the great salon of Europe. The Piazza follows the ancient Byzantine model of grouping together temporal power (the Ducal Palace), and spiritual power (the Basilica of San Marco). These are the most dazzling and visited monuments in the city. Generally, they are flanked with messy-looking tourists in crumpled shorts who follow harassed guides waving flags to keep them under control. The din of multilingual babble sounds like the simultaneous translation system of a great international conference gone berserk. On exhibition in the Piazza are architectural styles ranging from Byzantine through the empire canon of that much-hated and short-lived conqueror of Venice, Napoleon Bonaparte.

From the lagoon, visitors enter the Piazetta, the smaller square that leads into San Marco, passing two very high Byzantine columns: one with a Sassanian bronze-gilt winged effigy of Saint Mark, and the other with an early image of Saint Theodore, the first patron saint of Venice. On the right is the enormous Ducal Palace, once the center of the republic's political and civic life, and the most important building in the city. It was originally a sort of fortress, and was rebuilt in the twelfth century in the Byzantine style by Doge Sebastiano Ziani. Work on the palace continued for centuries as the republic expanded and larger rooms of state were needed, or as parts of the palace were destroyed by fire and needed replacing. It is a building of great elegance and lightness, whose Venetian Gothic facade consists simply of two colonnades of exquisite ogival arches supporting a sophisticated repetitive geometric pattern of white and pinkish beige bricks.

Basilica of San Marco (detail).

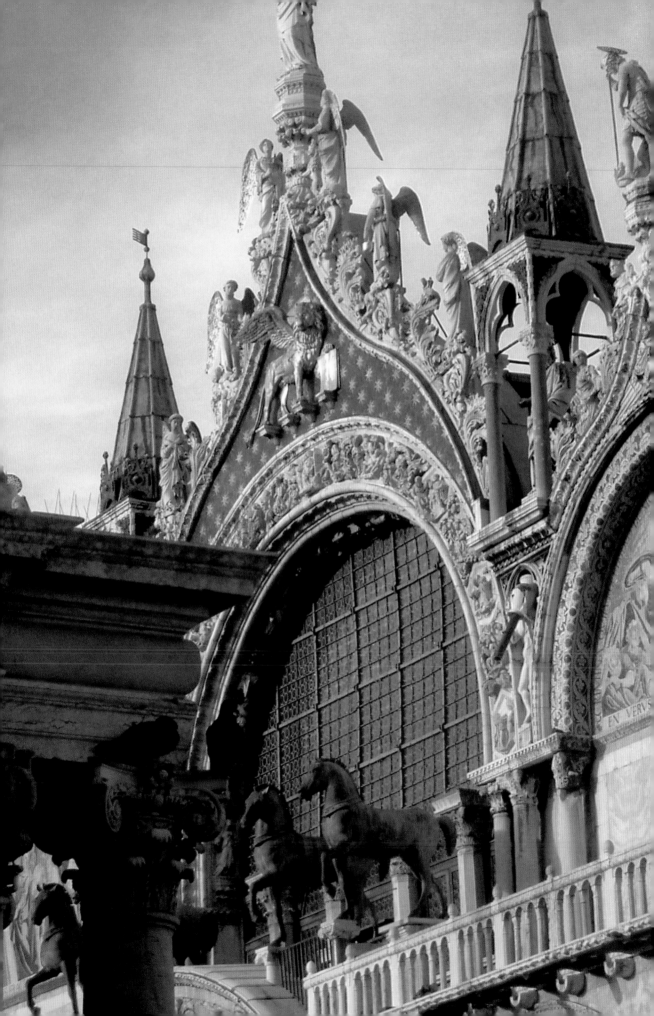

The highlights of the Ducal Palace include its inner courtyard and the Scala dei Giganti (the Giants' Staircase), the Sala dell'Anticollegio (with wall paintings by Tintoretto and Veronese), the extravagant Sala del Collegio and Sala del Senato, and most of all the Sala del Maggior Consiglio, originally decorated by Bellini, Carpaccio, Alvise Vivarini, Gentile da Fabriano, and Pisanello. After a great fire destroyed their work in 1577, the Sala was redecorated by Tintoretto, Veronese, and Palma Giovane.

At the start of the ninth century, Venice chose to become part of the Byzantine Empire, located in what today is Turkey. In brief, Byzantium's capital, Constantinople, named after its builder, the Emperor Constantine I, became the multilingual center of a great civilization and also the capital of what was left of the Roman Empire. The early Venetians, who considered themselves Romans, escaped the marauding barbarians who had brought down the Roman Empire and sought refuge in the marshes that would become Venice. While they were not willing to live under his tutelage, the recognition of the Byzantine emperor as their supreme authority clearly indicated that they would not become part of feudal Europe. The extravagance of the Byzantine liturgy, the richness of its vestments, the magnificence of its artistic creation, and the splendor of its churches impressed the early Venetians. Being part of what was essentially an Oriental empire forced Venetians to think about exploiting the riches of the East, and they built ships to do just that. And it was their vast trading fortunes that enabled the Venetians to build a sumptuous city. Trade financed their importation of fabulous treasures and dressed the patricians in luxurious stamped velvets and silks. It was soon said that money was the true religion of Venice, just as it was in Alexandria. In both, Arabs, Christians, and Jews forgot their differences in the excitement of becoming rich.

The links between Venice and Byzantium became stronger after the Sack of Constantinople in 1204, an infamous effort led by the French crusaders in which the Venetians participated. It resulted in the richest art looting of all time, and great treasures flowed from Byzantine coffers and monuments into Venice. Many of these treasures, along with the records of

The Doge on Jeudi Gras in Venice (detail),
Francesco Guardi, about 1775, oil on canvas, 26 x 39", Louvre, Paris.

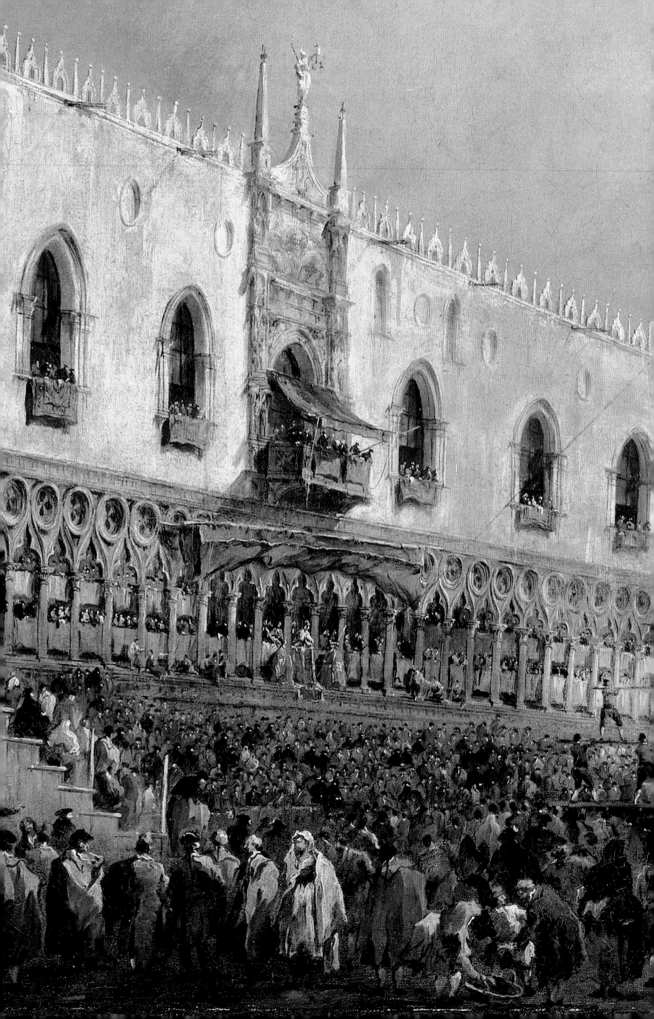

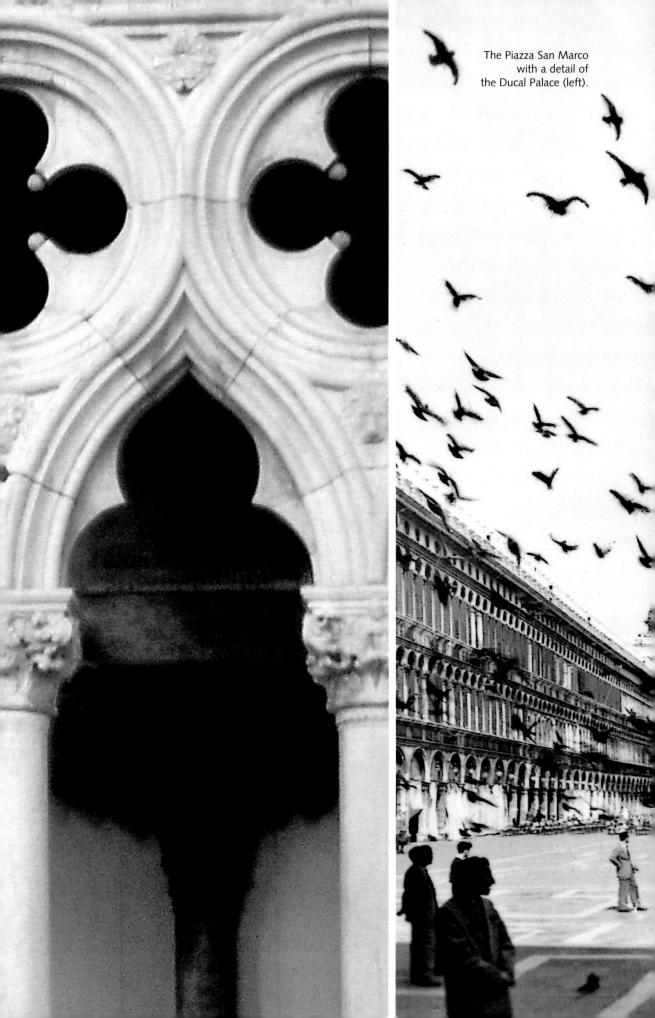

The Piazza San Marco
with a detail of
the Ducal Palace (left).

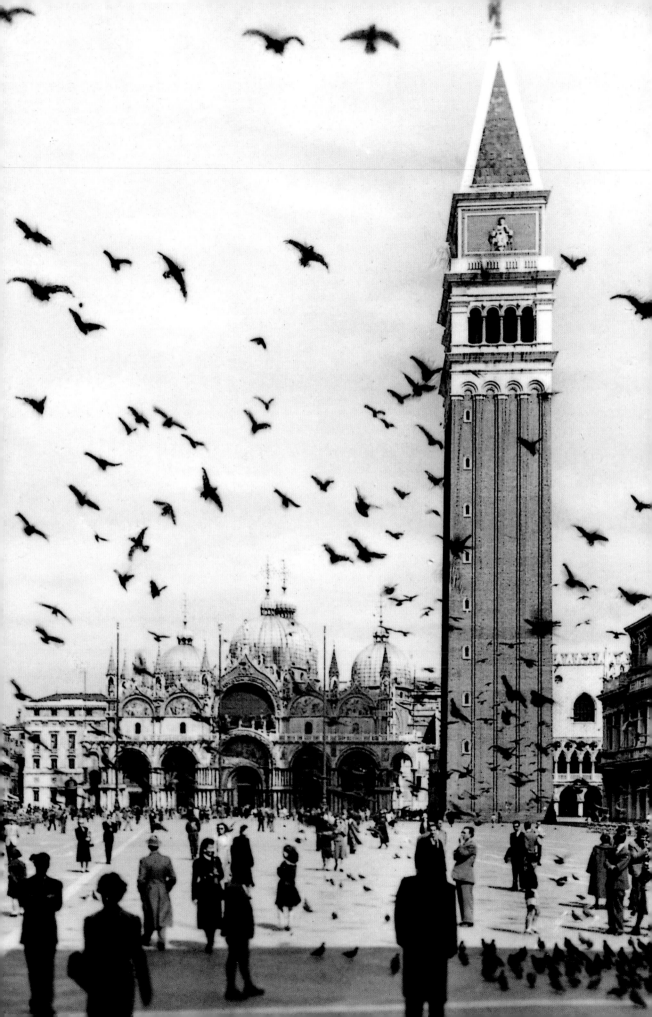

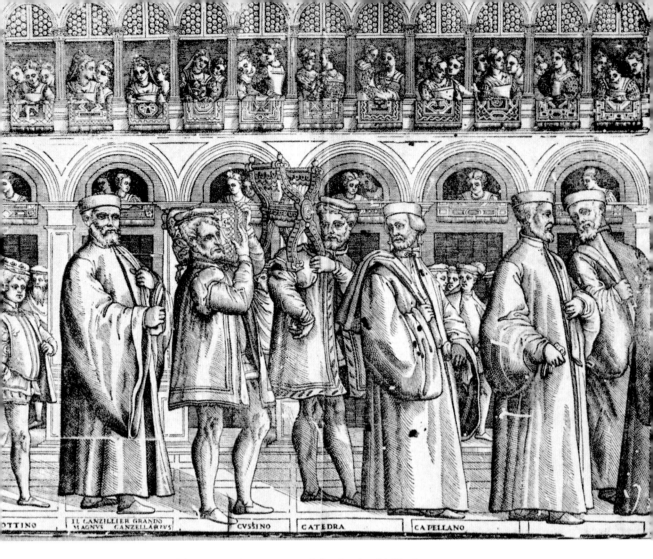

OTTINO IL CANZILLIER GRANDO / MAGNVS CANZELLARIVS CVSSINO CATEDRA CAPELLANO

Procession of the Doge in San Marco on Palm Sunday, Mattia Pagan,
about 1556–1569, wood cut, Correr Museum.

Venetian conquest, are now housed on the left of the Piazetta in the
splendid Biblioteca Marciana, whose design was set out by the sculptor and
architect Jacopo Sansovino and finished by Vincenzo Scamozzi. Filed away
in its archives and exhibited in its beautiful Golden Room are some of the
world's most important Byzantine illuminated manuscripts, as well as
incredible silver gilt, bejeweled, and enameled book bindings. A staircase
designed by Alessandro Vittoria leads to the room, which is decorated with
medallions and panels by Titian, Tintoretto, and Veronese.

The most palpable evidence of the all-important link to Byzantium is,
of course, the Basilica of San Marco. Two smaller churches preceded it, one
was dedicated to Saint Theodore, and the other was built to house the relics
of Saint Mark, the other patron saint of Venice, that were stolen in 829 from

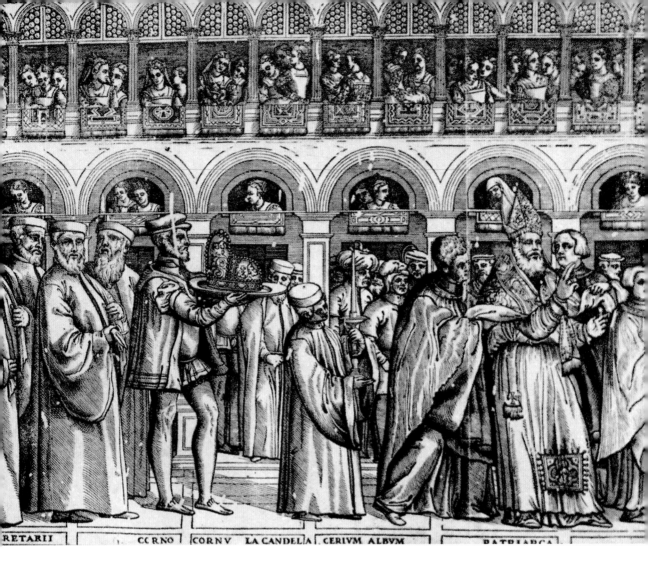

RETARII CERNO CORNV LA CANDELLA CERIVM ALBVM PATRIARCA

a church in Alexandria and secretly transported to Venice under a pork shipment by two Venetian merchants, one from Torcello, the other from Malamocco. The saga of the stolen bones continued two hundred years later, after a Venetian doge and his leading ecclesiastical official hid them for protection and died without telling anybody where the bones were. The church lost its legitimacy without the relics, and prayers were said for many months until, according to legend, a light appeared from Heaven and shone on their hiding place. Walls magically crumbled, Saint Mark's bony arm raised itself, and this Grand Guignol came to an end. In 1063, Doge Domenico Contarini ordered the new basilica to be built, and the two earlier twin churches, each devoted to one of the city's patron saints, were knocked down. The crypt of the old St. Marks, which still contained the

relics, became incorporated into the new basilica in 1075, which had the Church of the Apostles in Constantinople as a model. The patronage of Saint Theodore was finally eclipsed.

Byzantium was famed for its architecture, stone carving, sumptuous objects, mosaics, and jewelry, particularly its champlevé enamels. All these can be found in St. Mark's, along with northern Italian Romanesque and Gothic sculptures in profusion. Work on the basilica was done by Byzantine artisans, their Venetian assistants, and then schools of Venetian artists who carried on the traditions. Generations of art historians have tried to sort out who did what, but what really matters is the glorious effect. The five domes that dominate the Greek cross-inspired plan, their supporting arches and columns, and a few walls are all covered in glowing mosaic scenes on a gold background. The floors are made up of tesserae, or chips, of black, gray, vermilion, and beige marble in both geometric and anthropomorphic shapes. A splendid carved iconostasis leads to the greatest treasure of the church, the Pala d'Oro, or Golden Altar. This enormous assemblage of Old and New Testament scenes in champlevé enamel (of both Byzantine and Venetian origin) are embedded into a frame of solid gold and highlighted by thousands of precious stones and pearls.

The facade is equally remarkable, with lavish mosaics and marble carvings. A central porch containing the legendary Quadriga was inspired by Roman triumphal arches. The four gilded bronze horses, looted from Byzantium during the Sack of Constantinople, are among the finest large antique bronzes in the world. They are also famous for being taken to Paris by Napoleon for the Arc de Triomphe du Carousel in 1802 and were only returned in 1815. Copies have been put on the facade, and the originals are in a museum inside the basilica. The basilica's cupolas sprout clusters of stars that create a dazzling effect against the blue sky. In front of the basilica are three bronze flagpoles, appropriately covered with Nereid's, tritons, and other sea monsters that could have slithered out of the Grand Canal, flopped across the Piazetta, and fixed themselves on these standard-bearers of the Venetian Republic. And nearby, of course, is the large, brick Campanile, or bell tower, with its pointed marble roof and Sansovino sculptures.

Treasury of the Basilica of San Marco: The archangel Michael, Byzantine icon. (repoussé relief in gold with enamel highlights), 10th or 11th century.

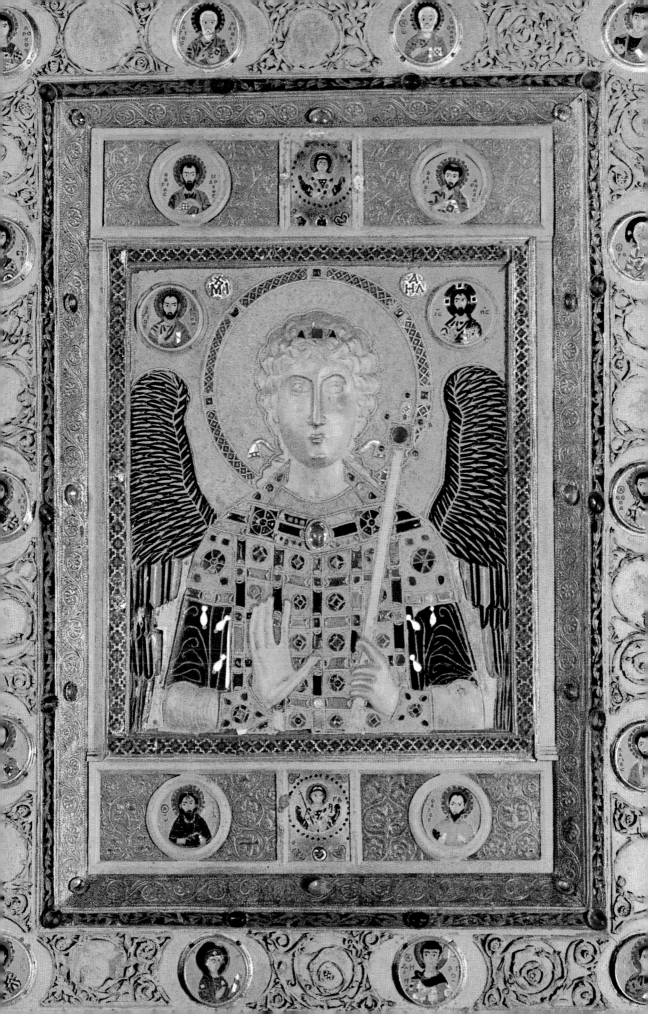

It was built between the tenth and twelfth centuries (its roof was added in the fifteenth century) by people with a Twin Towers mentality; they wanted the Campanile to be the tallest tower anywhere, something that could be seen by nearly everyone in the city or approaching Venice. In the early morning of July 2, 1902, structural defects caused the tower to collapse into itself, just like the Twin Towers, causing a near earthquake in the vicinity and a rising cloud of dust. It was soon rebuilt, but much of Sansovino's sculpture was destroyed.

On each side of the Piazza are the procurators' palaces, the Procuratie Vecchie and the Procuratie Nuove, which were built to house part of the vast administration needed to govern the Venetian Republic. The old palace, with its adjacent blue clock tower and the Café Quadri, is a rather undistinguished structure built by Bartolomeo Bon in the early Renaissance style, with boring rows of arches. Opposite is the new procurators' palace built by Scamozzi (who also built the Marciana Library) and completed by Baldassare Longhena. The new palace abuts the Marciana library and contains a wonderful antiquities museum, state archives, and other displays. The Piazza is closed off on its far side by the Ala Napoleonica, or Napoleonic Wing. This carved, white marble building still has a beautiful Empire ballroom; splendid rooms of state; and statues, reliefs, and plasters by Antonio Canova, Venice's leading neoclassic sculptor. It also houses the Museo Correr, a large exhibition space and decorative arts museum.

This great civic center lent itself to public gatherings and lavish processions that reflected the power and richness of the Venetian Republic. Several days a week, it served as a produce market, with lots of little stands. The Basilica of San Marco also inspired major processions, and these were painted by Gentile Bellini and others. Naturally, there were numerous spectacles in and around the Ducal Palace, and many moved onto the Grand Canal when the Bucentoro, the ship of state, carried the highest dignitaries of the republic. All this involved lots of dressing up, something the Venetians still enjoy. The citizens of this elegant city like wearing masks and capes and putting together eighteenth-century costumes for Carnival; many Venetians also spend a large part of their budgets buying

Preceding double-page: The Gran Caffè on the Piazza.

clothes to look sexy and fashionable. Appropriately, the best shopping street for clothes, the Merceria, is right off the piazza, cutting through the clock tower and stretching over various bridges all the way to the Rialto.

Another great attraction of the Piazza is, of course, shopping. Arcades run the circumference of the Procurator's palaces, the Napoleon wing, and the Marciana Library, and they shelter dozens of shops in every price range. In the luxury category, there are two splendid jewelers: Missaglia and Nardi. Nardi, like Codognato, makes jeweled Blackamoors but also sells exquisite pietre dure boxes using rare marbles and semiprecious stones in addition to jewelry for everyday use. It is the perfect place to buy your most opulent presents. Missaglia sells Italian jewelry along the lines of what is sold in the great shops on Milan's Via Napoleone and, for that matter, on the Place Vendome. If you are looking for fine silver, both shops stock a wide variety as does Takazian; the latter also includes fine Burano lace on its shelves. But, if you hanker after lace, just behind the Piazza is the sales-room of Jesurum which, in addition to modern production sells antique lace that would be at home in a museum, and it is priced accordingly. There are variety of shops for Venetian glass; the stores of the two leading firms—Pauli and Venini—are among the best in Venice for traditional pieces, while Palesa has a good representation of more sculptural contemporary design. And the Libreria Sansovino is, undoubtedly, the best book shop in the world for publications about Venice and the Veneto and has a range of art books, including catalogues of major exhibitions.

The Piazza is also the best place to people-watch. or those who want to do so in great comfort, there are three cafés—the Quadri, the Florian, and the Lavena—that will serve you the most expensive coffee, ice cream, or aperitif in the world as you sit behind a round table on a comfortable caned armchair. But after all, this price of admission includes a concert, a theater seat for everything that is happening around you, and the most mesmerizing setting you will ever find. So, it's a good deal for the price and may be the only thing you really *have* to do in Venice. It's no wonder that everybody proposes, "Ci vediamo in Piazza," and that the Piazza is the starting point of most Venetian adventures.

PIAZZA SAN
o Correr Museo
Archeologico
Nazionale

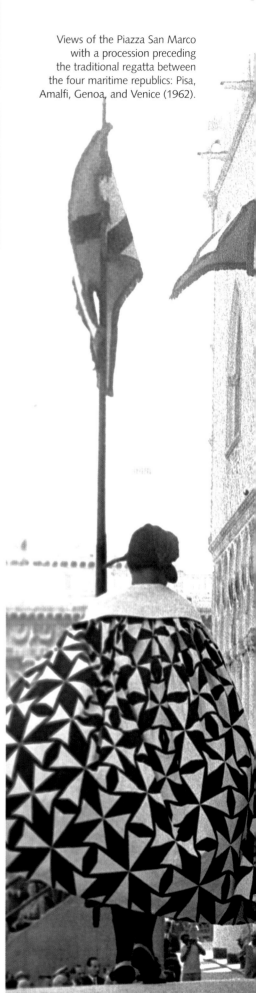

Views of the Piazza San Marco with a procession preceding the traditional regatta between the four maritime republics: Pisa, Amalfi, Genoa, and Venice (1962).

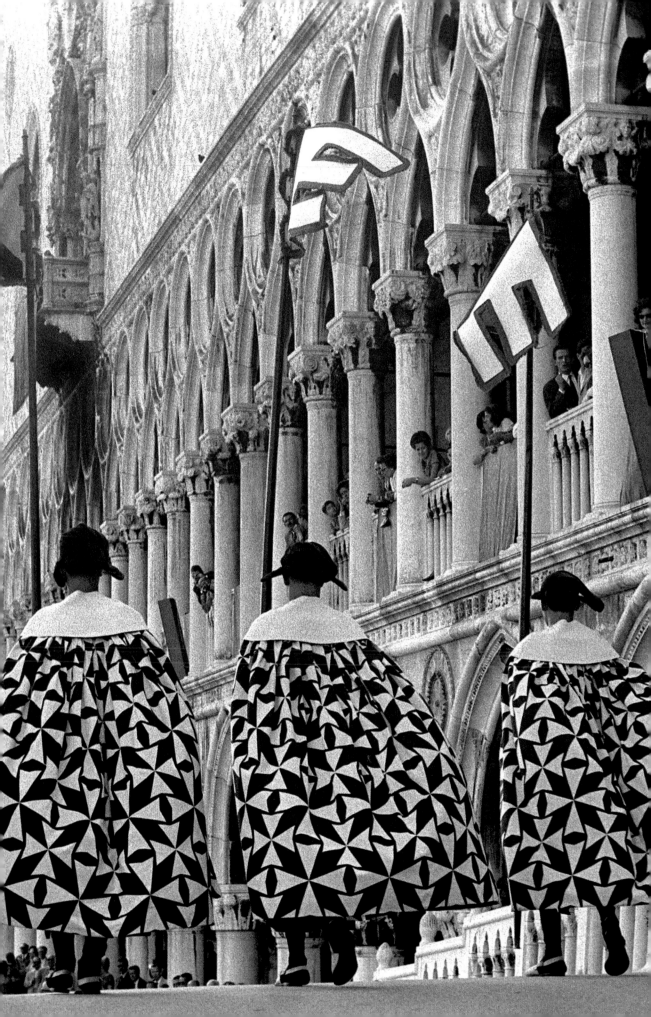

Ca' d'Oro

It's not just tourists who look out for, and can't recognize a Ca' d'Oro or Golden House as they travel down the Grand Canal. Though its name implies it is the grandest building in Venice, the Ca' d'Oro is actually dwarfed by the contemporaneous Doges' Palace, and seems unassuming compared to such grand baroque edifices as the Ca' Rezzonico, Ca' Foscari, or Palazzo Labia. While the Ca' d'Oro, with its lace-like traceried loggia, is the most delicate and sophisticated of Gothic private palaces, it certainly doesn't compare to Europe's legendary cathedrals. Yet its strange and sumptuous blend of Oriental and Occidental architectural and decorative vocabularies distinguish it from northern architecture of the period, whose goal was to bring man closer to God through the use of ever higher stone arches and tracery. It has suffered over the years and as it has been ripped apart and put back together, and moreover, its

The Ca' d'Oro on the Grand Canal, around 1880.

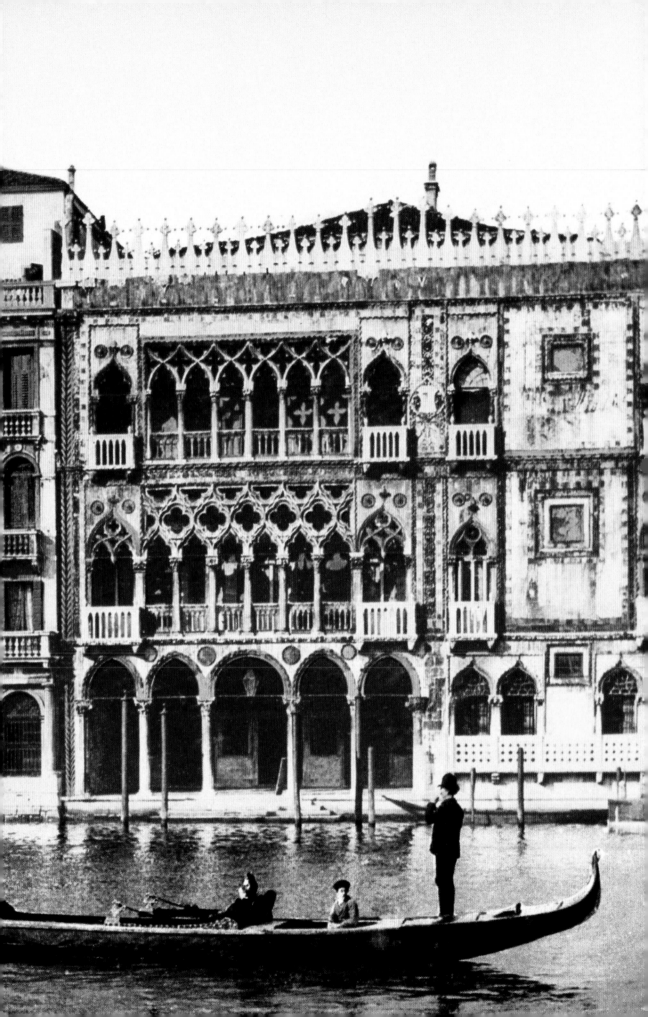

character was completely changed when it became a museum at the end of the nineteenth century. Notwithstanding, it was once the flashiest of Venetian palaces, whose coloration compared with the blue and gold clock tower on the Piazza San Marco that delights children, who wait for its revolving figures to start their hourly circular promenade and furiously bang their hammers against an expectant bell, rather like laborers at Vulcan's forge.

In 1406, the patrician Marino Contarini married Soradamor Zen, the daughter of the previous palace's owner. Contarini was clearly more interested in impressing his peers with the extravagance of his decorative program for the palace than in coming closer to his Maker. In 1431 he hired the French painter Jean Charlier, referred to by Venetians as Zuane da Franza, to gild several elements on the new facade, including the freestanding balls on the crenellations of the roof, small lions sculpted on the corner capitals at the tops of the ogival arches of the windows, and much more. The facade already contained decorations of antique green porphyry, and serpentine, and the sheer lavishness of this rather gaudy creation was highly original and must have been very impressive.

Contarini also hired the master stonecutter Matteo Raverti, renowned for his work on the Doumo, in Milan, the well-known sculptors Giovanni and Bartolomeo Bon, and other Venetian and Lombard artisans to embellish the house. Contarini died in 1454, followed by his son ten years later, and after that the house went through a great many hands. So many, in fact, that the facade's splendid decoration faded, and the house became a ruin and was sold in 1846 to the Russian grandee Prince Alexander Troubetskoy, who gave it as a present to his mistress the dancer, Maria Taglioni. The independently rich Taglioni already owned two splendid palaces on the Grand Canal, and thus added the Ca' d'Oro to her collection. Unfortunately, she hired the engineer Giambattista Meduna, who proceeded to gut the palace, even throwing out the Bartolomeo Bon staircase, to the horror of the legendary John Ruskin, who watched chunks of the palace floating away by barge. Fortunately, the house was bought in 1894 by the Venetian baron Giorgio Franchetti (whose beautiful

granddaughter Afdera married the American movie actor Henry Fonda), and he did his best to put it back together. Franchetti used the palace to house his splendid art collection, which included the major Italian masterpiece, *The Martyrdom of St. Sebastian* by Andrea Mantegna painted for Sigismondo Gonzaga. This is one of the most sensual of all Venetian paintings, an emulation of the splendid classic nudes of antiquity in the form of a saint closely linked to the plague that devastated the population of Venice.

Franchetti died in 1922, leaving his palace and collections to the state, who brought in many other works of art, including fragments of frescoes by Giorgione and Titian that once covered the facade of the nearby Fondaco dei Tedeschi, paintings by Giovanni Bellini, and other major Venetian artwork, tapestries, marbles, and terra-cottas. The Galleria Franchetti also houses the best collection of small Renaissance bronzes in the region by Paduan sculptors such as Riccio, Antico, and Bellano. This is particularly important as it was the arrival of Donatello in nearby Padua that brought the art of bronze casting to northern Italy and Venice in particular. Padua, of course, had a major university, where humanism flourished, and the small bronzes that imitated antique models were highly appreciated there. Donatello made the astonishing reliefs and Corpus for the high altar at Paudua's Santo Cathedral, as well as the equestrian portrait of Erasmo da Narni, known as the Gattamelata. It is also thanks to Padua that the churches of Venice are filled with bronze statues by Alessandro Vittoria, Tiziano Aspetti, Niccolo Roccatagliata, Alessandro Leopardi, and so many others.

Bridges

There is no city in the world with as many bridges as Venice. These passages link the city together and are central to any question asked by those who have lost their way. ("Primo a sinistra, cento metri, arrivi al ponte.") And they are perfect viewing platforms for the ochre tints of buildings, dark green water, and puffy clouds in a Tiepolo sky. Miracles of design, the bridges fuse brick and marble, wood and iron, and their gradation and length lends variety to any walk around the city. At the end of the fifteenth century, a study counted only thirteen bridges, as Venetians then were ferried from one bank to the other on traghettos from thirty-three points in the city. By 1580, Francesco Sansovino counted "450 bridges, if not more, in stone," but after the fall of the Venetian Republic, many canals were filled in and unnecessary bridges were destroyed.

Some bridges were named after activities or products for which they were known; there was a bridge of beans,

The Bridge of Sighs.

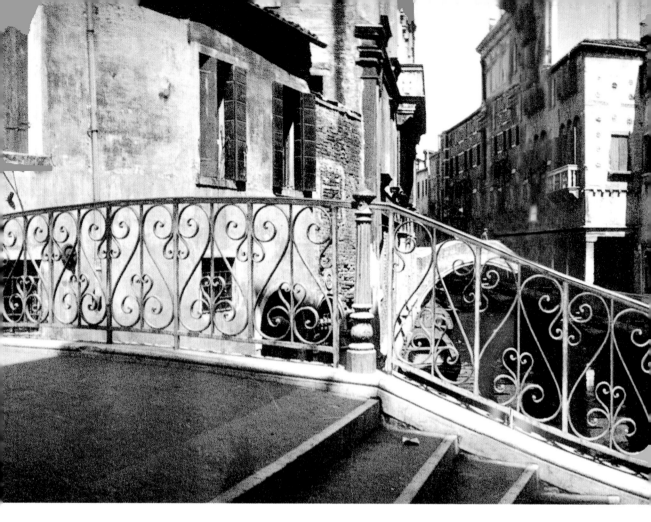

A view of Venice by Mariano Fortuny, about 1910.

anchors, assassins, fists (where fights took place) vinegar, dice, milk, lamb, and horses, among others; the connection has often been lost in time. While most bridges were permanent, others were temporary, like the great span of linked boats that went across the Giudecca canal for people to cross from the Zattere to the Church of the Redentore, or another that crosses over to Santa Maria della Salute. Both of these temporary bridges were put together for a few days each year for processions celebrating the anniversaries of the end of the plague.

The most famous bridge, thanks to Shakespeare's *The Merchant of Venice* is the Ponte del Rialto, which was the first stone bridge to cross the Grand Canal, linking the two largest islands of Venice. Before the Rialto, there were three wooden bridges near here, and when they collapsed, Palladio, Michelangelo, Sansovino, and other leading figures submitted plans for a redesign in the contest of 1557. Appropriately, an architect named da Ponte won. The stone

bridge he designed was tall enough to allow galleys to pass, strong enough to hold dozens of small shops typical of this mercantile city center, and beautiful enough to take away the breath of anyone who passes through it on their first visit to the city. Though it seems to divide Venice in two, it's only a five- minute walk from the Piazza San Marco. This is because the Grand Canal is curved rather than straight and the shortest route from the Rialto to San Marco runs right through the heart of the city rather than navigating its periphery.

Undoubtedly, the next most famous bridge is a suspended one. It links two buildings, the Doges' Palace and what used to be its prison. The Bridge of Sighs was the last glimpse of the free world before those caught up in the webs of intrigue and justice of the *reppublica* crossed over to their rat-infested cells. It particularly appeals to those coming from or going to a truly enjoyable moment in time, rather like members of Stalin's Politburo watching trains leave for Siberia.

Ghetto

The very mention of the word "ghetto" evokes a sense of disaster. There was the Warsaw ghetto, where Jews were herded and segregated during World War II, and where they fought desperately for their lives against heavy German artillery. There was the Frankfurt ghetto, from which the Rothschilds emerged, where residents had to step down in the gutter and raise their hats to the rare passing Christian as a mark of respect, and today a ghetto refers to any urban area where the unfortunate are segregated from the privileged.

The first ghetto was created in Venice on March 29, 1516, by a decree stating that "the Jews must all live together in the complex of houses in the ghetto near Girolamo." *Gettare*, the Italian word from which the name is derived, means to cast, and the area in Canareggio where Venice's Jewish quarter was set up was first known as the *Nuovo Geto* or new foundry. Two gates were put up, which were locked at midnight, effectively separating the Jewish community from Christians. The purpose was to discourage intermarriage or social intercourse of any kind as well as to protect Christians from "blood rituals," the polluting of wells and other fictitious crimes that had been invented in the Middle Ages to justify the persecution of a people accused of the murder of Christ. Ghetto did not then have the terrible connotations it carries in the post-Holocaust world, but Venice's role in setting up the first such institution has not reflected well (quite unfairly, actually) on the city.

Jews arrived in Venice from all over Europe as of the thirteenth century, and were part of the *shoa*, or odyssey, of the Jewish people who had to leave the Holy Land after the destruction of the Second Temple in Jerusalem.
were often persecuted, limited in the activities they were allowed to pursue, and chased out of many countries for refusing to convert to Christianity. Jews

The interior of the Levantina Synagogue (founded in 1541), Ghetto Vecchio.

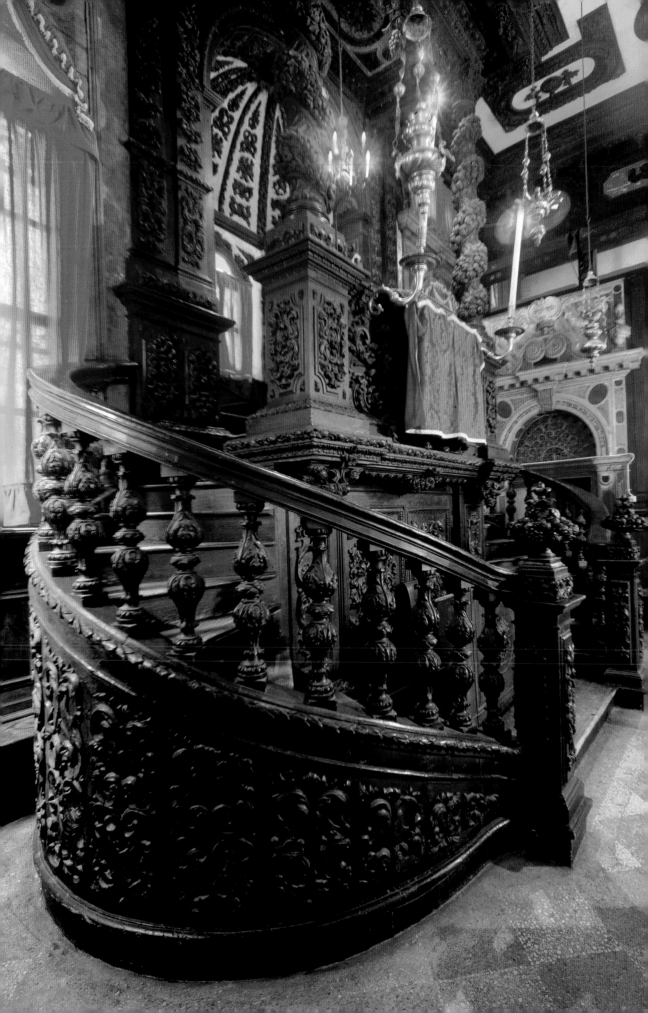

were the only people allowed to engage in money lending in Europe, since Christians were then precluded by canonical law from charging interest and were not allowed to own property or engage in most professions. As successful moneylenders, Jews accumulated quite a lot of cash and gold, and they became Europe's leading jewelers and bankers. Collecting interest, foreclosing on loans and mortgages, and carting off the goods of Venetian merchants who had overextended themselves financially was, needless to say, not conducive to popularity, and led to constant arguments.

Venice had spent a lot of money on wars, suffered economically from several plagues, and badly needed capital and financial skills, which encouraged Jews to settle in the republic. Originally, they were free to live anywhere; some went to Mestre on the mainland, while others settled in the city. As the Jewish community increased, the number of banks grew along with the envy of the Venetians, and by 1516 it consisted of seven hundred unpopular people distinguished by their traditional black clothes, beards, dietary habits, and religious observance. Jews were a major financial force by day but were segregated every night, a social phenomenon not uncommon to cities in the United States until World War II, in Paris in the years of the Dreyfus case, and in most European cities after the rise of Nazism, which for practical purposes destroyed Jewish life in Europe. Shakespeare's vicious creation of the rapacious moneylender Shylock has, quite unfairly, established an ongoing connection between Venetians and anti-Semitism.

When the ghetto was established, it was considered a haven for Jews who had nowhere else to go, having been chased from many of the countries where they had lived for centuries. The ghetto could not expand because the republic would not give it any more space. By the seventeenth century, it had a population of more than five thousand people and five beautiful synagogues for members of different branches of Judaism. The only solution to the housing problem was to add floors to the existing buildings, and a distinguishing factor of the ghetto quarter today is that many houses rise a few stories higher than elsewhere in the city.

The Jewish community was very heavily taxed, the republic obliged the banks to make large loans to pay for its Turkish wars, and many moneylenders found themselves going broke. By the end of the eighteenth century, the

community had shrunk by two-thirds, only a small percentage of whom were solvent. On July 7, 1797, Napoleon's invading troops opened up the ghetto (as they had done in Frankfurt). There were no more night guardians, and the French conquerors planted a Freedom Tree in the Campo di Ghetto Nuovo to indicate that Jews were now able to live wherever they wanted and free to choose their life's work. Today there are only a few hundred Jews living in what was once the ghetto. There is a Jewish old age home, a few shops for tourists looking for their roots that sell such kitsch souvenirs as rabbis and fiddlers in colorful Murano glass, and a few signposts of the old banks that were distinguished by colors (the *banca rossa* and the *banca verde* for example). The synagogues, known as *scuole* or schools, have been restored, and most are quite beautiful. The most sumptuous is the Spanish School, which was built in the 1500s and remodeled in 1635 by the renowned architect of the Salute, Baldassare Longhena. Thanks to its perfect proportions, rich woodcarving, and rows of arched windows sheathed in multicolored marble, it can be compared to many of the finest churches in Venice. The Italian School, built in 1571–75, is modest in comparison, and the Scuola Levantina in the Old Ghetto has a superb lectern by Andrea Brustalon, Venice's most famous woodcarver, as well as a striking Renaissance facade that stands out from the dreary adjacent buildings.

Jewish life in Venice came to an end after several centuries on the nights of December 5 and 6, 1943, when two hundred victims were rounded up, taken to a concentration camp at Fossoli, and deported to Germany where most died. As we know from *The Garden of the Finzi Continis*, by Giorgio Bassani, Italian Jews had by this time voluntarily assimilated into their adopted country, and the Nazi-led persecution came to their total astonishment. One friend of mine learned when his aviation lesson was canceled, another when he was kicked out of school.

Well worth a visit is the small Museum of the Jewish Community, which has manuscripts, Torahs, and other household and religious artifacts which, like all Judaica, often reflect the artistic influence of the countries where the Jews lived. On the main piazza of the ghetto is a series of reliefs devoted to the Holocaust by the Lithuanian sculptor Arbit Blatas, and there is a large Jewish cemetery on the Lido that fell into disrepair after the war, when there was nobody to care for the graves. It was recently restored by the Scheurs, an American family.

Grand Tour

It is said that the culmination of a wellborn Englishman's education was the grand tour, which consisted of a trip to the Continent, with Italy as the main event, and a stay in Venice as the highlight. The purpose was to become a humanist, expand a young man's viewpoint beyond Eton, Harrow, and Oxbridge, and study ancient languages and civilizations. And incidentally, to sow his wild oats before returning to England to find an equally wellborn wife and domesticity at home. The gaming houses, or *ridotti*, of Venice were the perfect place to get into trouble, gamble, and have short affairs with pretty courtesans. These ladies spent a good part of each day on an *altana*, or wooden platform, taking in the sun so that they could bleach their hair and brown their skin, distinguishing themselves from wellborn ladies whose pale skin was never exposed to the elements. The *ridotti* were basically elegant brothels, where every vice was acceptable; many an Englishman lost his virginity in Venice.

The grand tour followed a fairly well-defined passage, from Plymouth to Naples and Sicily; via Paris, Germany, and Switzerland; over the Alps (no small feat in the eighteenth century) to northern Italy; followed by long stays in Venice, Florence, and Rome. The young men were accompanied by a "bear," a sort of tutor, private secretary, and chaperone, who carried large letters of credit that would be honored wherever they traveled. There were so many young, grand tourists conducting their grand tours that English tearooms soon proliferated in the centers of Italian cities. Many young men stayed for several years, continuing their studies, or simply having a good time.

The two main legacies of the grand tourists were the Palladian influence on the English country house and the importation of Italian paintings,

Breakfast in The Loggia (detail), John Singer Sargent, 1910, oil on canvas, 20$^{1/2}$ x 28", Freer Gallery of Art, Washington D.C.

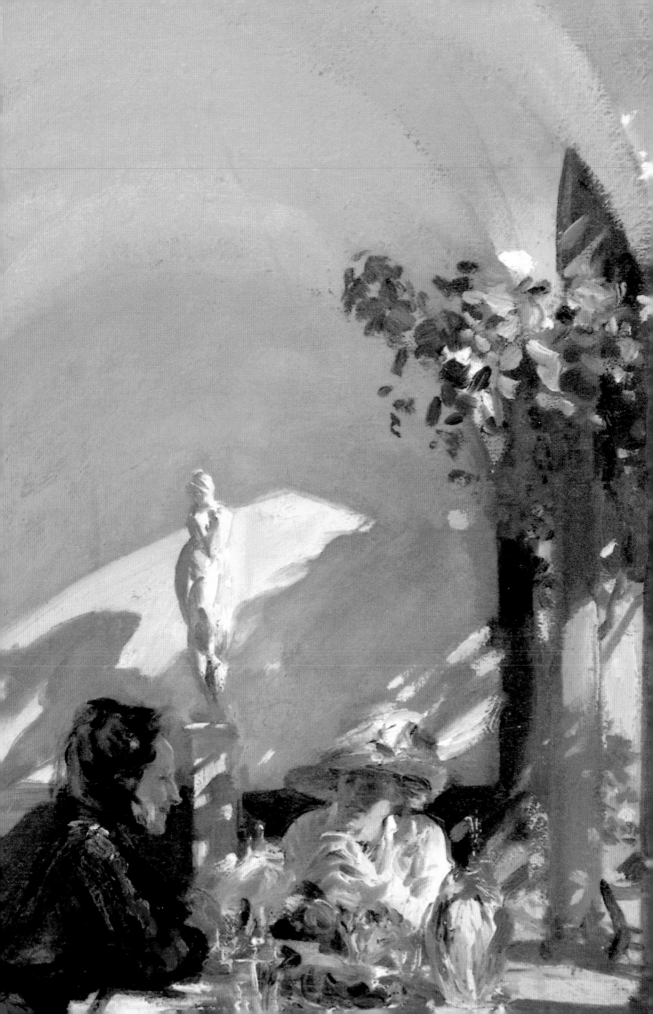

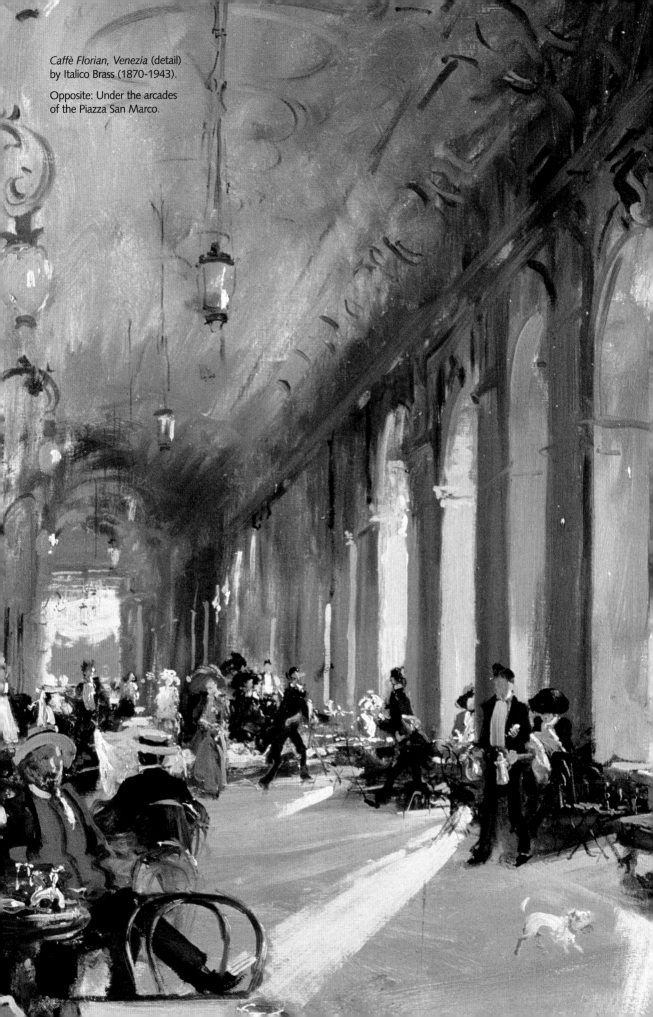

Caffè Florian, Venezia (detail)
by Italico Brass (1870-1943).

Opposite: Under the arcades
of the Piazza San Marco.

drawings, sculpture, and works of art into Britain. Italian art filled the Englishmen's great stately homes and only started to emerge on the art market after two World Wars and socialist taxation practically ruined the once immensely rich British aristocracy. A young man generally waited to go to Rome to have his portrait painted by Pompeo Batoni, often with an antique fragment in hand, or standing amid ancient ruins. But most of all, grand tourists adored paintings of the Venetian canals, processions, streets, and piazzas, which are known as vedute, or views of the city, and were truly the rich man's version of travel souvenirs. They bought them during their trips to Venice or ordered them after they left, often through the English consul Joseph Smith, a major collector who stayed in Venice after his term of office had ended and lived in a large, painting-filled palace. Smith was the main promoter and dealer of the most popular vedute painter, Antonio Canal, called Canaletto; he arranged for Canaletto to paint the famous twenty-four views of Venice for the duke of Bedford's dining room, and eventually to travel to London where he painted splendid views of the city (looking rather like a boat-filled Venice) and country houses of such grandees as the earl of Warwick. Consul Smith was also responsible for the magnificent Canalettos and a great many other truly major Venetian paintings in the collection of the English royal family.

Canaletto is reputed to have used the camera obscura, an optical instrument that reflected the view he intended to capture onto his canvas, so that he could trace it mechanically, which may have contributed a sense of rigidity to his works. He filled his space with a limited number of small, dynamically painted figures, rather like punctuation, and was genial in encapsulating the ever-changing color of the Venetian sky and the dark green murkiness of its canals. He had a deep influence on his nephew, Bernardo Bellotto, who traveled and worked so closely with Canaletto that it is often difficult to know who painted a particular Venetian scene. What actually distinguishes them is what, not how, they painted. Bellotto traveled and worked throughout Italy, and he was particularly drawn to classical antiquity in Rome, whereas Canaletto's foreign work was mostly in England.

In some ways, the vedute of Francesco Guardi were the most enchanting. He was inspired by Canaletto, but only started working two generations later,

A poster from the exhibition "Tiepolo. Ironia e Comico" at the Cini Foundation (from September 3rd to December 5th 2004) showing his work *Carnival Scenes* (about 1754).

OLO TIE

OMICO

IRONIA

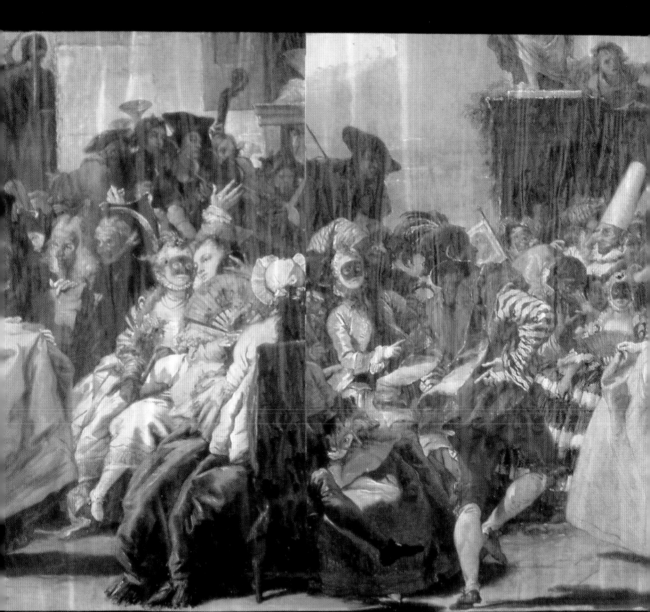

Giandomenico Tiepolo, Il Minuto. Parigi, Museo del Louvre.

RGIO CINI
ORGIO MAGGIORE
mbre 2004
alle 18.30

REGIONE DEL VENETO
GIUNTA REGIONALE

fondazione
GIORGIO CINI

FONDAZIO
VENEZIA, ISOLA DI
3 settembre

Tutti i giorn

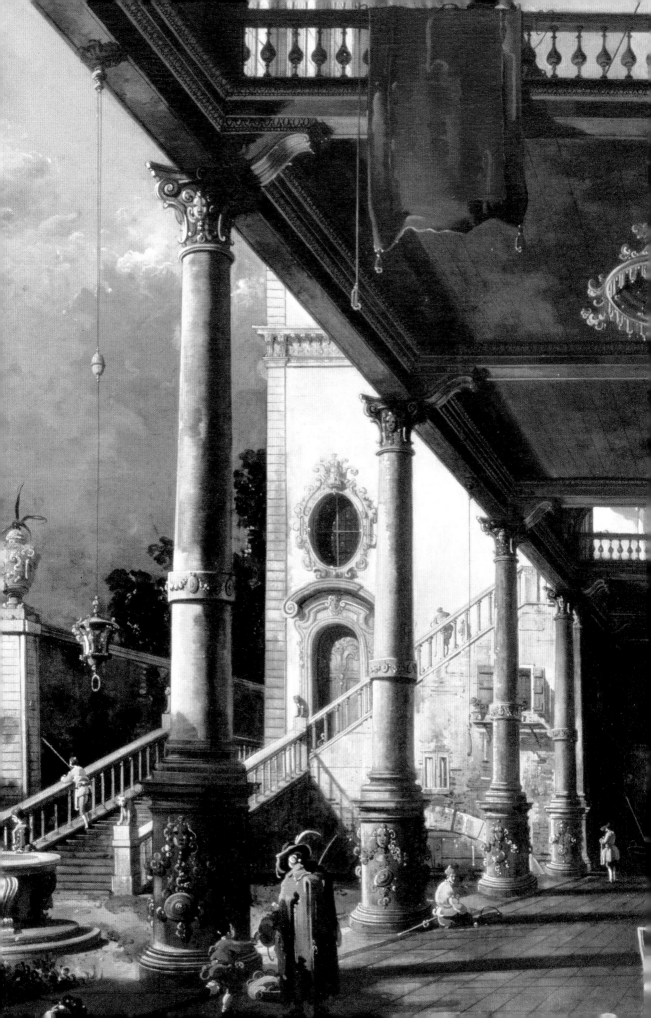

and was trained by his brother Gianantonio, who was little more than a provincial copyist. Francesco Guardi's brushstrokes are remarkably free and brilliant. The greatest virtuoso of the vedutisti, he produced literally thousands of small paintings of Venice for the large international clientele who all wanted souvenirs. There are a great many practically identical versions of these small views that Guardi turned out to make a living, but he hit his stride with larger works, such as a Venetian procession of acrobats descending a tight rope, or the marine activity around the Rialto. It was in these paintings that he created images that are burned in the mind's eye forever and that fully captivate the brilliance of Venetian life. This was also the achievement of one of the earliest vedutisti, Luca Carlevarijs, who worked fifty years before Guardi. He was the most precise and accurate of all the painters and specialized in the large processions on and around the Piazza San Marco. The best reporter of the glory days of the Venetian Republic, Carlevarijs misses nothing in his representation of hundreds of important personalities of the republic participating in the annual outing of the doge in his *bucentaro*, or ceremonial ship of state. The entire government is packed on the red gilded vessel, with the Venetian aristocracy sailing alongside in their family colors, and people of all classes crowding the streets or watching from their balconies.

But the grand tourists didn't limit their Venetian souvenirs to vedute. They bought the enchanting genre scenes of Pietro Longhi, which depicted everything from the arrival of the first rhinoceros in Venice to a struggling doctor yanking out a tooth; the skillful, pretty, but slightly repetitive *capricci*; mythological scenes and cow-filled landscapes of Francesco Zuccarelli, Giuseppe Zais, or Michele Marieschi. They could get their portrait painted by the finest pastelist of the period, Rosalba Carriera, or buy wonderful drawings by Giambattista and Giandomenico Tiepolo, and many others. And for truly serious collectors, of which there were quite a few, Consul Smith could rustle up a great Titian, Tintoretto, or Veronese. Nearly everything was shipped back to Britain's great estates, and the many masterpieces that have survived wars, gambling, and taxation are still among the houses' crowning glories.

Capriccio with a Colonnade (detail), by Giovanni Antonio Canal, known as Canaletto, 1765, oil on canvas, 16$^{1/2}$ x 12$^{1/2}$", Gallerie dell'Accademia, Venice.

Biennale

There are certain days of the year that are fixed in the datebooks of anyone interested in contemporary art including dealers, collectors, museum curators, art advisers, artists, critics, auction house experts, enthusiasts wanting to demonstrate their own relevance, and, as prices escalate, commodity traders, hedge fund managers, and simply the very rich who hope to increase their fortunes by speculating on the hottest new artists. These personalities travel the world to take part in a handful of events that define contemporary art. Fairs in Basel, Miami, Sao Paolo, and Paris, as well as the contemporary art sale weeks in New York and London, are all included in this circuit. Undoubtedly, the happening that is the most fun is the Biennale, in Venice. In other cities, art fairs become just one of several simultaneous happenings, participants tend to disperse, and a feeling of unity is difficult to attain. But at the Venice Biennale, the art flock is thrown together in such an insular and captive setting that the festival permeates the city; no one dares to leave and risk missing a great party, a new artist, a piece of gossip, or a painting that they have coveted for years, offered by one of the marauding dealers.

Every hotel bed, restaurant table, and barstool is taken over by the art groupies. Museums bring over their prestigious trustees, rich collectors cling to their private curators, and everywhere talk centers around the price of art. Each day, there is a large lunch party on the roof of the Guggenheim Museum, generally given to raise money. Dealers pour Bellinis in the rentable palaces on the Grand Canal, and Sotheby's takes over the Palazzo Volpi for hundreds of their best clients. There are fabulous happenings all over the place, and everyone hangs out of windows and waves to their friends passing by. The Biennale itself takes place in the Giardini Publici, a large park past the Arsenale and an

The Venice Biennale, 2003.

di uello spettato

DREAMS AND co

Esposizione Intern

Venezia - 15 giugno /

Ritardi e Rivoluzioni / Delays and Revolutions a cu

nuove letture e traduzioni

stabile. Esso al contrario dipende spesso da

LA BIENNALE La Zona / The Zone realizzato da gru

Spazio di confronto e piattaforma di dialogo dove si sperimenta una n

Spazio di confronto e piattaforma di dialogo

Smottamenti / Fault Lines

La mostra suggerisce uno spazio condiviso, privo di confini tem

contemporanea e paesaggi in cambiamento. a

cura di Igor Za

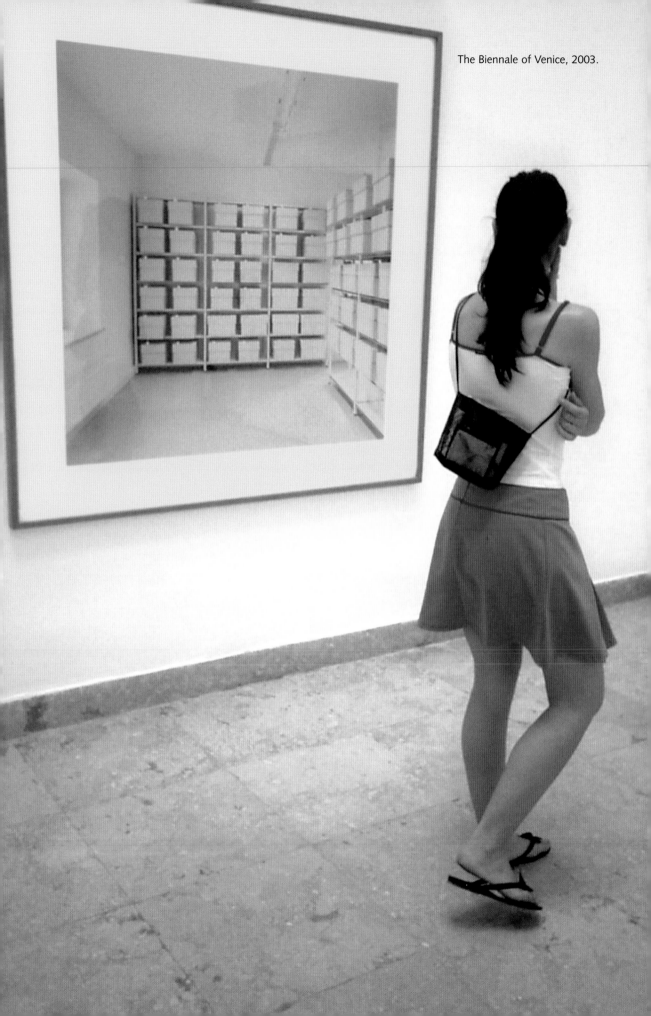

The Biennale of Venice, 2003.

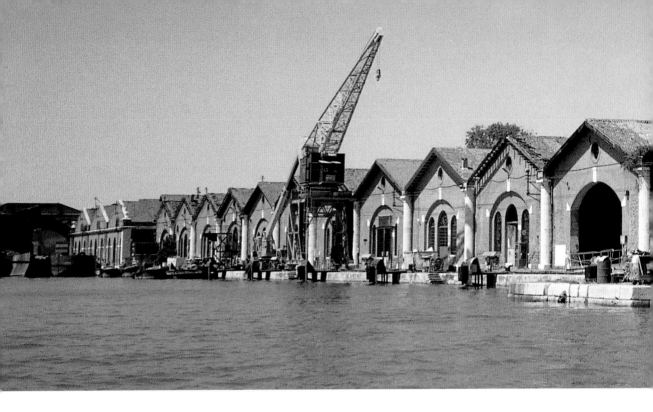

The Arsenale, site of the Architecture Biennale.

obligatory stop for the vaporetti that travel between the Lido and the Piazza San Marco. For the past few years, abandoned buildings of the Arsenale have been used as an exhibition space for the audiovisual works that make up a great part of what is displayed. The giant art fair is part of a cultural organization known as La Biennale di Venezia, which also organizes a movie festival on the Lido and other international festivals of the performing arts including dance, music, and theater. The Biennale was conceived by Riccardo Selvatico during his tenure as mayor of the city in 1893. Soon after, work began on the Palazzo delle Esposizione. This is now the Italian pavilion and the largest and best placed of all the buildings. Under the direction of the Venice Biennale, the Ca' Pesaro, Venice's museum of modern art, opened in 1902, and the first foreign pavillion, that of Belgium, opened in the gardens in 1907. Gradually, other countries built their own pavilions, often inspired by their national styles. Each had a commissioner, who decided what would be exhibited, with an emphasis on recent movements or artists. In 1920, there were exhibitions of impressionists, postimpressionists, and Die Brücke. Two years later came the first retrospective on Modigliani, and so it went until the Biennale closed in 1942 for the duration of the war.

The Biennale reopened in 1948 with the first public exhibition of Peggy Guggenheim's collection in Europe, and under the new director Rodolfo Pallucchini, the exhibitions in all the pavilions were devoted to the cutting-edge art of the day. It was at the 1948 exhibition that Peggy Guggenheim met the great Renaissance art critic Bernard Berenson, whose books she had avidly studied. Peggy enthusiastically told the distinguished art historian how much she admired him and his work, to which he answered, "In that case, why did you buy all this?" To be seen in the Giardini were one-man exhibitions of Braque, Matisse, Raoul Dufy, Max Ernest, and Jean Arp. The American pavilion, which opened in 1950, exhibited the work of Arshile Gorky, Willem de Kooning, Alexander Calder, and Jackson Pollock, artists that were a revelation to many Europeans, not to mention Americans. It is fair to say that the two most important exhibitions for any contemporary artist are organized at the Museum of Modern Art in New York and the Biennale in Venice. And it goes without saying that there is enormous pressure on their commissioners to choose one artist over another, and always much disagreement with their choices.

The opening of the Biennale in early June is reminiscent of the giant schools of salmon that make their way upstream to lay their eggs every spring;

waiting in line, people push and shove, raising clouds of dust in the early summer heat and humidity. Then, they rush off to Harry's Bar to secure their tables and be among the first to recite the names of artists they think are either genial or impostors. Generally, the weightiest art groupies flee directly after the opening since they feel obligated to be in Basel when the Art Basel fair opens. Few have even had time to seriously visit the large exhibition, since they have all those parties to attend. There is nothing to buy at the Biennale, so collectors get edgy to arrive in Basel and purchase works by the hot new artists they have seen or heard about. Needless to say, the wily dealers will have a good supply of the right works on hand. Many galleries and collectors ask that paintings be returned before the Biennale closes, since they want to sell them after the—mostly incomprehensible—reviews in art magazines throughout the world have driven up their prices.

By the end of the summer, the pavilions have been half-emptied. And at the festival's end, the remaining paintings and sculptures (and audiovisuals, presumably on disk) are also sent home, hopefully now destined for museums or collectors. The totally empty, often oddly designed buildings are abandoned and must wait nearly two years to come back to life.

The Venice Biennale, 2003.

Film Festival

Count Giuseppe Volpi di Misurata, one of Venice's great patrons of the arts, lavished enormous sums to make Venice one of the great European centers of all the arts. It was under his guidance, and largely with his money, that the first film festival was hosted on the Lido in 1932 on the terraces of the Hotel Excelsior. Movie buffs may know that its first film, interestingly enough, was Rouben Mamoulian's *Dr. Jekyll and Mr. Hyde*.

The Venice International Film Festival is the oldest film festival in the world, and still one of the great draws of Venice in September. In 1937 the Palazzo del Cinema was built, and the following year a casino was opened. The elegant casino was particularly active during the festival, when an international film crowd filled the Lido's hotels after the beach season came to an end. It was then time for the queens of Hollywood, rather than the social dinosaurs of Venice, and above all for Cinecittà heroes; Angelo Rizzoli with his erect cigarette holder clamped between his teeth, Anna Magnani looking common and sultry in her décolletage, Gina Lollobrigida covered with diamonds and rubies, and Dino de Laurentis looking ever triumphant in his black tie, posing with an international cast headed by Daryl Zanuck and Jennifer Jones, Anatoli Litvak or Prince Aly Khan stalking a busty starlet.

The festival, now directed by Marco Müller, may have been eclipsed by the larger Cannes festival, but it continues to attract all the major names in the industry, who flock to Venice to promote their films. Volpi's son, Giovanni, has taken on his father's active role, and fills his palace on the Grand Canal and house on the Giudecca with movie stars. And it goes without saying that a Leone d'Oro, a Golden Lion, that is presented every year for the best film in the festival remains among the highest of honors in the industry.

Sophia Loren at the Venice Film Festival in 1958.

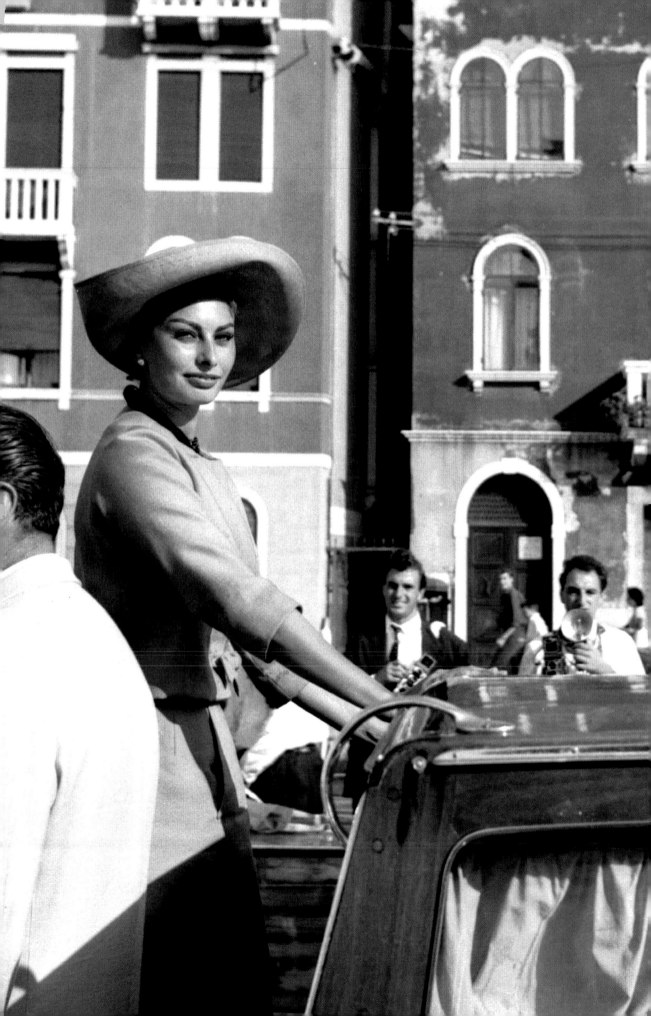

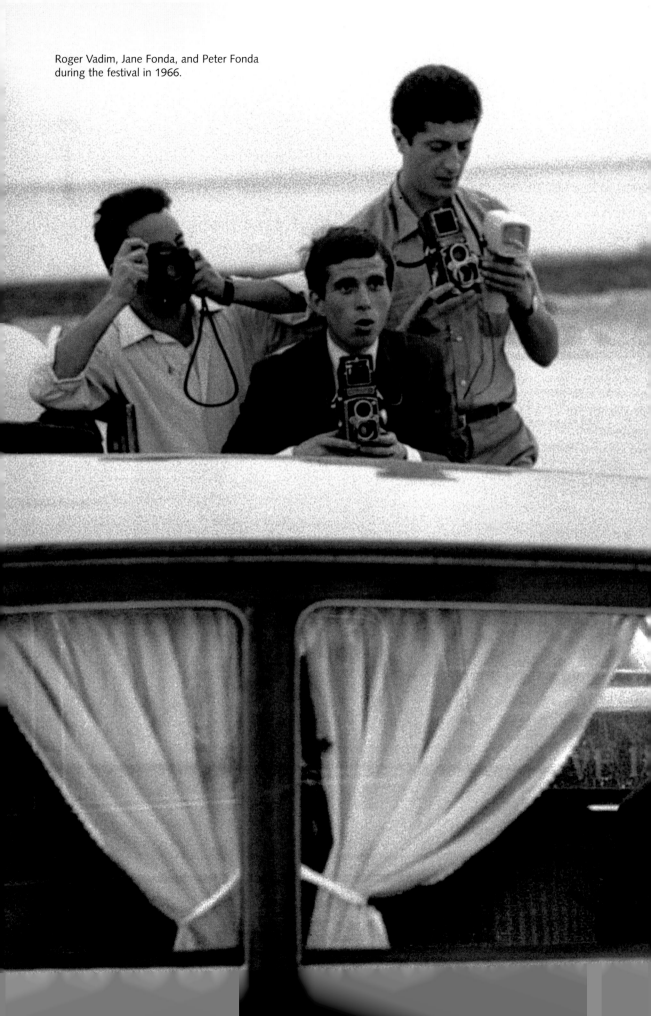

Roger Vadim, Jane Fonda, and Peter Fonda
during the festival in 1966.

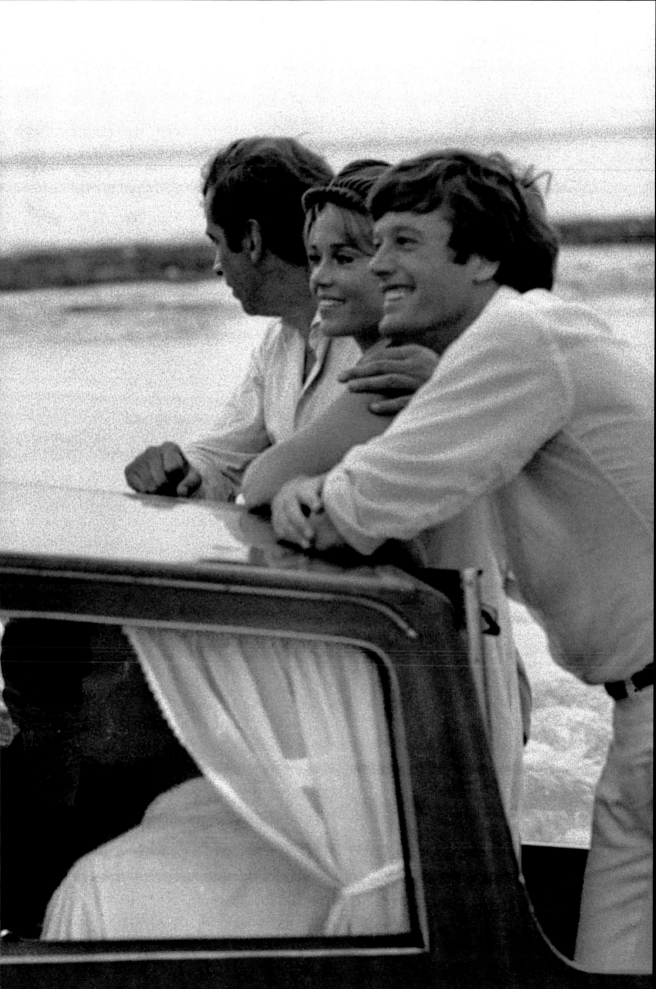

festival. If there is no performance, the theater and its memento-filled museum can be visited at specific times. Two nearby restaurants, Antico Martini and Taverna La Fenice, are very elegant places to go after or before a performance (before is better since Venetians and exhausted tourists go to bed early).

The tiered, gilded interior of La Fenice, the opera house in Venice

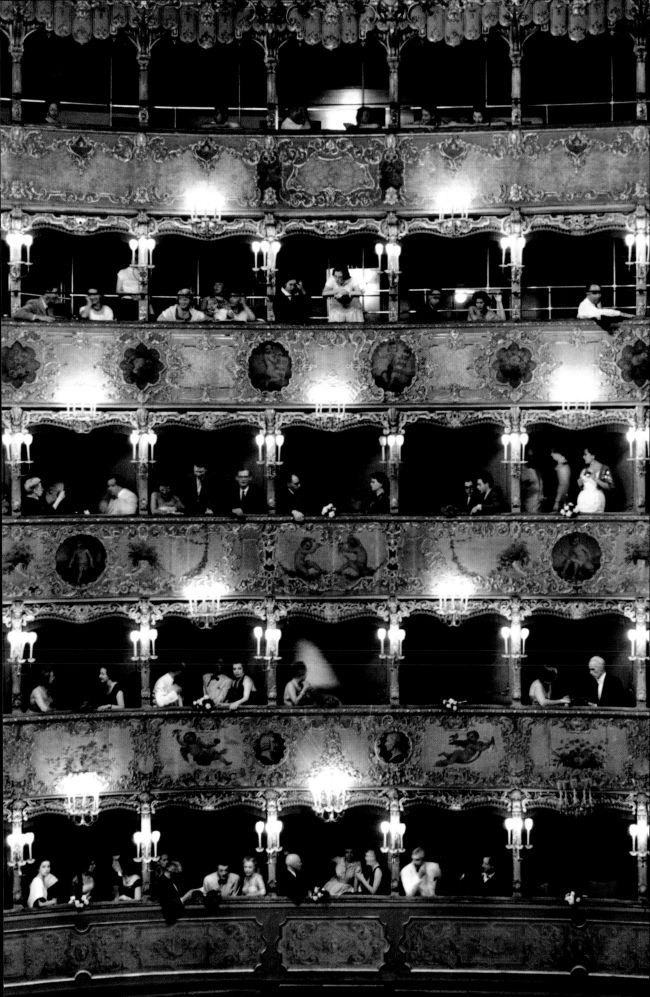

Patronage

The difference between charity and patronage is that the latter can confer immortality by means of anything from a small plaque to a public building. Venice owes a great deal to the patrons of the past as well as those of the present. Today, there are Venice supporters' groups from nearly every country in the world—including two in the United States—and they are ferociously competitive. Each year, the presidents of these committees gather in Venice and kneel before the Venetian Superintendent of Monuments, replicating the pose of donor-patrons of the Renaissance. Rather than seeking just recognition, they beg the Venetian Superintendent of Monuments to let them restore anything important with the money they raised by giving fancy dress parties and organizing cruises for their rich friends and acquaintances. In addition to these social philanthropists, Italian industrialists, Swiss watchmakers, and even couturiers hoping to improve their images, all donate vast fortunes to restore the city. After World War II, Venice was in tatters, plaster peeled off palaces and polluted the Grand Canal, smaller canals were putrid and smelly, frescoes were blackened by soot from candle smoke, and altarpieces obscured by dark varnish. Today, the facades of the Grand Canal palaces are as pristine as those of the Via Montenapoleone, Milan's great shopping street. Every altarpiece looks as if it had just been restored in the studios of the Metropolitan Museum of Art, and every church facade glistens chalky white in the sun, with much of its sculpture skinned by overenthusiastic restorers.

In our time, there have been three outstanding patrons of Venice's cultural life: Giovanni Agnelli, Giuseppe Volpi, and Vittorio Cini. The

Giovanni Agnelli in Venice in 1970.

Agnellis, founders of Fiat, are Italy's most powerful family, and their private foundation rebuilt the Palazzo Grassi as a museum. The enormous marble-faced palace was built in the eighteenth century by the architect Giorgio Massari for the Bolognese Grassi family who had become Venetian patricians thanks to their large contributions to wars against the Turks. It became a hotel and then a bath house, and was bought by Fiat in 1948 and rebuilt as a museum in 1985 under the guidance of two of Italy's most renowned architects and designers; Milan's Gae Aulenti, who later converted Paris' Gilded Age railroad station the Gare d'Orsay into the Musée d'Orsay, and Antonio Foscari, a talented Venetian aristocrat, descended from a ducal family, who lives in the Villa Malcontenta, a masterpiece of Andrea Palladio on the outskirts of Venice.

The museum instantly became a world-class institution thanks to vast funding from the Fondazione Agnelli. It organizes exhibitions on everything from the Phoenicians to Balthus, and is the center of life during Venice's art Bienalle. Agnelli, known to everyone in Italy as the Avvocato, was an Italian institution in his own right, a sort of replacement for the King of Italy. Handsome, incredibly rich, and powerful, with impeccable taste in everything from cooking and beautiful women to paintings and furniture, he was a leading art collector who enjoyed sailing his yacht, the *Stealth*, into the lagoon. Agnelli died in 2003.

The Avvocato's father, Edoardo Agnelli, died in 1935. Two of his fellow tycoons then were Count Vittorio Cini and Count Volpi di Misurata, both of whom lived in Venice. The close friends singly and jointly industrialized the mainland around Venice (a mixed blessing) and their fortunes were made largely during Mussolini's reign, when Count Volpi was appointed Minister of Finance. He owned most of Libya during those days, and Misurata in Libya was added to Volpi's family name when he was made a count by the King of Italy. In 1930, the Venice Bienalle passed from the control of the Venice City Council to the Italian state, then under Mussolini's control with Volpi as minister of finance as well as president of the reorganized Bienalle. It was also Volpi who gave a multidisciplinary character to the Bienalle, which organized Italian

Detail of a fresco by Michelangelo Morlaiter exhibited in the Palazzo Grassi.

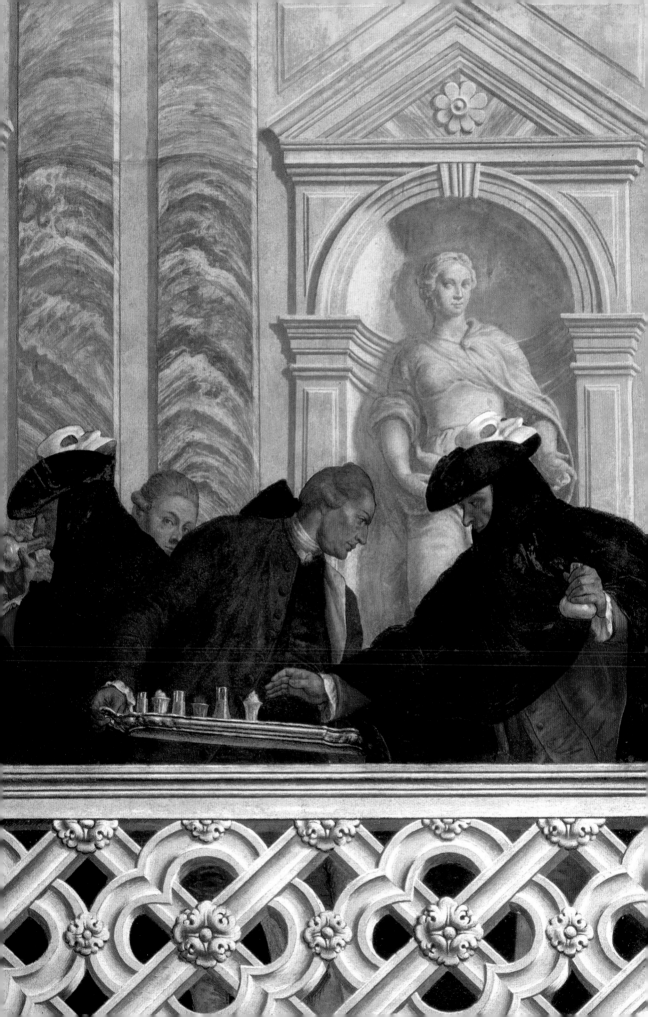

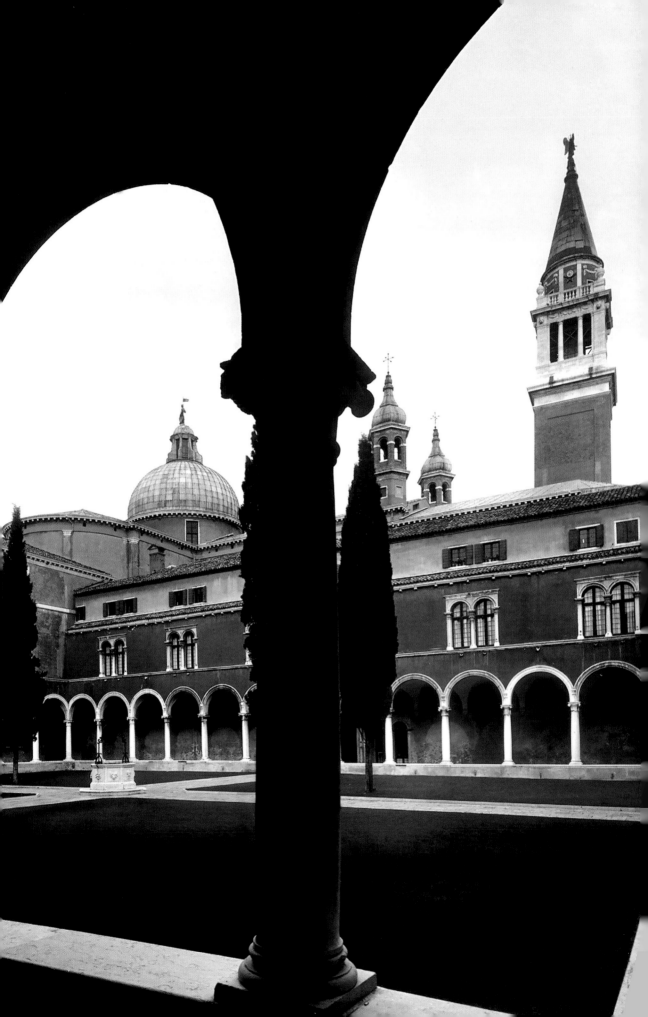

exhibitions abroad, and encouraged performance of contemporary music, dance, and theater.

It was Cini, however, who made the major bequest to Venice. In 1951, he decided to house his private foundation on the island of San Giorgio Maggiore, directly opposite the Piazzeta San Marco. He bought the monastery on this "Island of Cypresses" and rebuilt it as a center of learning, a memorial to his only son, Giorgio, who died in a plane accident in 1949. The foundation is an internationally respected art history institution, and houses an important research library, major collection of old master drawings and manuscripts, and an even more important collection of rare books. The Foundation also has an open air theater, where plays and concerts are presented in the summer. The Cini Foundation has become to Venetian painting what the Bienalle is to modern art. During his lifetime, Count Cini lived in a smallish palace in the Sestriere of Dorsoduro that has been convereted to a museum that houes his art collection which includes paintings by Botticelli and Pontormo among others, and an excellent collection of Renaissance works of art.

The garden of the Cini Foundation on the island of San Giorgio Maggiore.

Casanova

The person most closely linked to licentiousness in eighteenth century is undoubtedly Giacomo Girolamo Casanova. And Venice, with which he is always linked, was then one of Europe's bawdiest cities. Men disguised in masks stalked women, courtesans abounded, and the gambling houses, or *ridotti*, were havens of misbehavior. Much of what we know about this seamy side of the Republic comes from Casanova's memoirs; 3,600 pages first published in several volumes by Leipzig's renowned Brockhaus and then translated into most European languages. These memoirs were widely read as risqué novels, and were popular in Victorian England, where they were hidden in the back of bookshelves and read under the sheets.

Casanova was born in Venice's San Sammuele parish in 1725. He was the oldest son of an actor of Spanish descent, who died when Casanova was 8, leaving him with his actress mother, Zanetta, who was always somewhere on tour. She sent him to study in Padua, where he learned violin well enough to join an orchestra, and was a brilliant student of classical languages thanks to his photographic memory. He returned to Venice where he became a parish priest, and then left for Constantinople and Cyprus, where he joined the military. He eventually returned to Venice, where he drank, gambled, and pursued ladies until the Republic sent him across the Bridge of Sighs to its dungeons. He escaped, and wandered around Europe becoming a friend of Voltaire, Empress Catherine of Russia, Benjamin Franklin, the king of Poland, and many Enlightenment figures. Eager to return to Venice but afraid to be put back in jail, Casanova wrote a history of the republic and was allowed to come back. The year of his death is unknown, as is so much of his strange life.

Portrait of Giacomo Casanova in 1774 by Alessandro Longhi.

Fortuny

At age 18, Mariano Fortuny y Madrazo set out for Venice with his mother and sister. He was enchanted. In these early years of the twentieth century, Venice was wholly fascinating, the reigning and timeless Oriental atmosphere charmed artists and society alike. This was a populace that was cultivated and cosmopolitan, a far cry from today's knapsacks and flip-flops. Coming from a Catalan background, Fortuny decided to make a life for himself in this city. In 1902, he met the talented Henriette Négrin from Paris, who would become his lifelong companion. In 1905, they bought the Palazzo Orfei (today known as the Palazzo Fortuny) on the Campo San Beneto, and set up a studio. The couple was filled with an artistic curiosity and energy that was truly out of the ordinary.

Fortuny was simultaneously a painter (he made frescoes), a photographer (he bequeathed wonderful images of fin-de-siècle Venice), a set designer (he worked with Gabriele D'Annunzio), a furniture designer, a collector, an inventor (he created a process for indirect lighting and patented two lamps, which are today produced by Andrée Putman). And a couturier.

Fortuny and Négrin immersed themselves in their fabulous library of collectible books and soaked up all there was to learn about Greek, Egyptian, and Byzantine culture, the Italian Renaissance, and the splendors of India. In search of the ideal and the timeless, they used draped velvet and pleated silk, dying them in infinite shades. And so they created what is now called the Venetian style. Their signature gown was named the Delphos, an homage to the Greek sculpture of the Charioteer of Delphi. Worn by Isadora Duncan, Eleonora Duse, Lilian Gish, the Marchesa Casati, and many others, the Delphos also inspired the Romanesque heroines of d'Annunzio and Marcel Proust. In 1949, Fortuny passed away. He remains one of the last great figures of Venetian history.

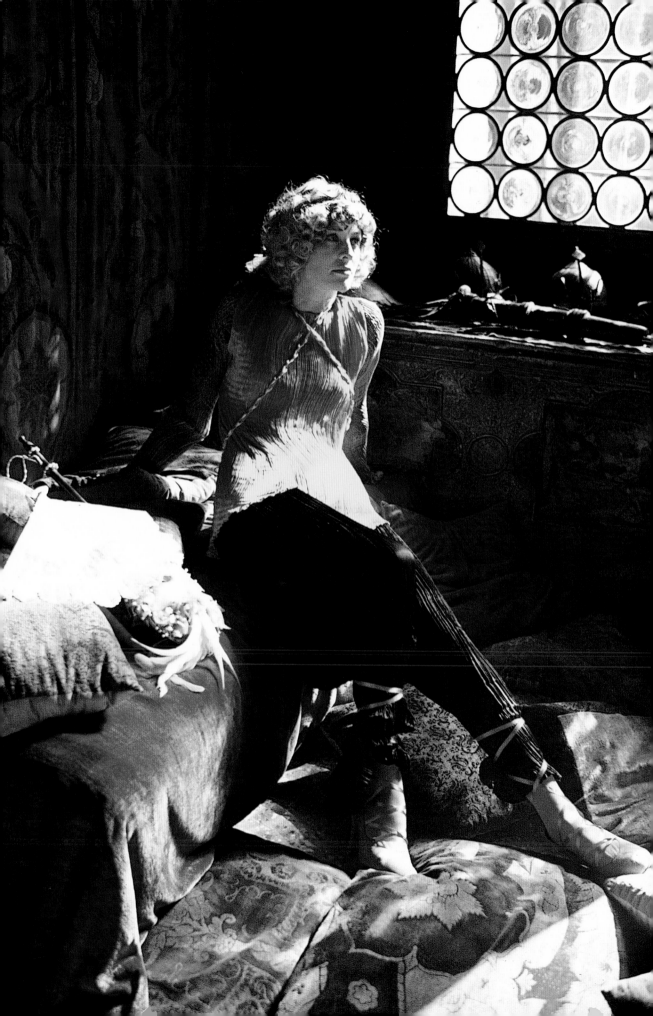

Princess de Polignac

Just after World War II, *Le Figaro* wrote in its obituary on the American expatriate Princess Winnaretta Singer de Polignac, "It will be impossible to write the chronicle of the twentieth century without including the salon of Winnaretta Singer Polignac on avenue Henri Martin and the palazzo on the Grand Canal."

Winnaretta Singer was born in 1865 in Yonkers, near New York City, the twentieth child of Isaac Merritt Singer, the inventor of the sewing machine. Singer had recently married Winnaretta's mother, Isabelle, who was bored stiff in the suburbs, so he sold the house and moved to London with his new family. After a bit of wandering, they ended up in Torquay, where Singer started building a new castle he called the Wigwam, and Isabella started organizing musicales, balls, and dinner parties for the local gentry. Singer died unexpectedly in 1875 and left a large fortune to his wife and daughters, who moved to Paris, where the French-born Isabelle felt very much at home; she was even rumored to have been Bartholdi's model for the Statue of Liberty.

Though Winnaretta showed a major interest in the arts, befriended Forain and Manet, and was active in the avant-garde, she was pushed to make a good, traditional marriage to the elegant hunter and shooter Prince Louis-Vilfred de Scey Montbéliard; a prenuptial agreement protected her fortune. On their wedding night, her husband was taken aback when he found Winnaretta in the bedroom waving a large umbrella and shouting, "If you touch me, I'll kill you!" Winnaretta was, in fact, a lesbian, although her sex life was discreet. Her sexual preference propelled her toward the music world, much of which was openly gay. Next, Isabelle married off Winnaretta's sister Belle Blanche to the equally grand Duke Jean-Elie Decazes, and the Singer sisters soon became an integral part of French society and its legendary salons; there were salons for literature,

Illustration of the Palazzo Contarini-Polignac, purchased by Winnaretta for her husband, Edmond, in 1900—today it is the property of the Duke and Duchess Decazes.

BLIGNAC. DECAZES.

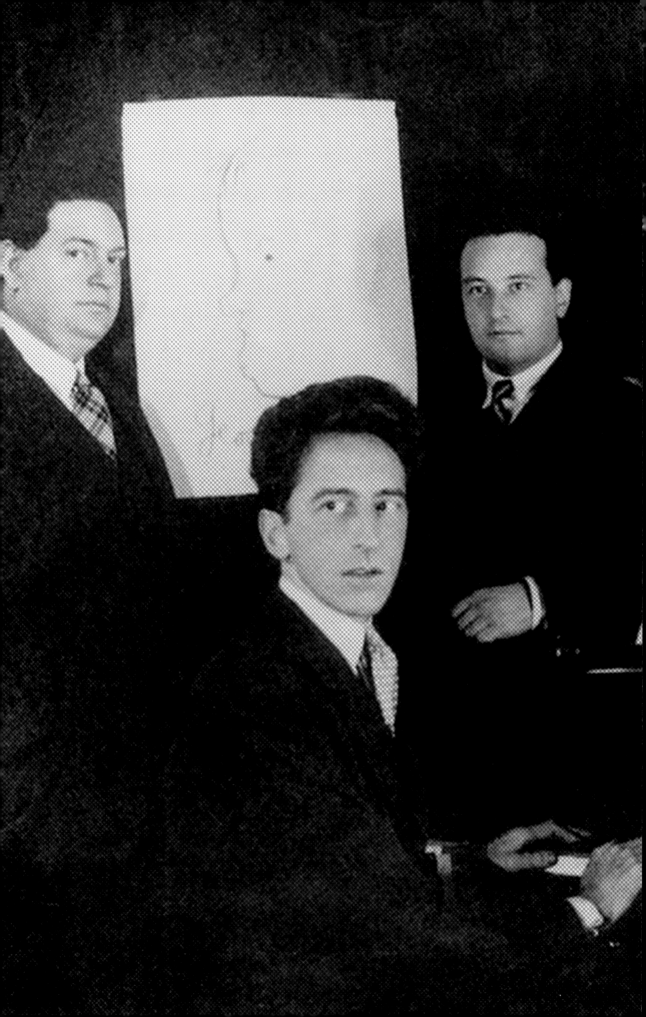

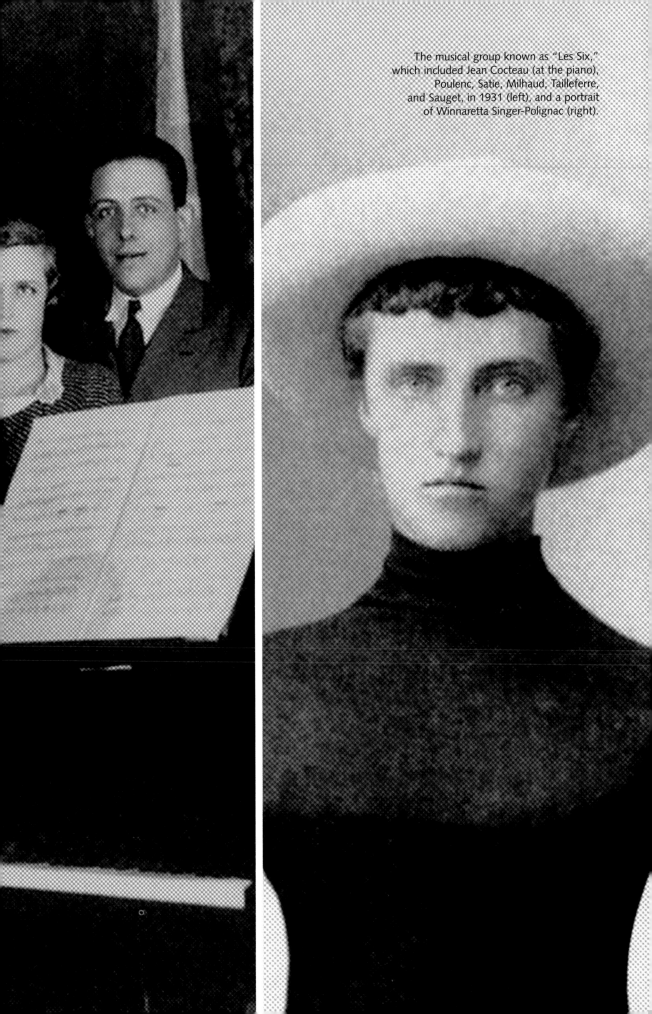

The musical group known as "Les Six," which included Jean Cocteau (at the piano), Poulenc, Satie, Milhaud, Tailleferre, and Sauget, in 1931 (left), and a portrait of Winnaretta Singer-Polignac (right).

art, music, or simply gossip, with a day of the week set for each reception. With their marriage unconsummated Winnaretta divorced the prince and left for Venice, where she rented a small palace on the Grand Canal. Shortly thereafter, she returned to Paris and launched herself into salon life; she turned to the Countess Elisabeth Greffuhle, the queen of French society, for advice.

She soon found a new husband who shared her interest in music and gave a purpose to her salon. Prince Edmond de Polignac, many years her senior, came from one of the grandest and oldest families in France. Unlike his robust, macho brothers who loved shooting every animal in sight, Edmond had been a sensitive child who studied the piano and even attended the Conservatoire. While his brothers first sowed their wild oats and then married girls from France's grand families, Edmond furtively admired handsome boys. He never made any money, dreamed of leading a happier life, and soon became the lover of Count Robert de Montesquiou, Proust's Baron de Charlus, who was France's most renowned aesthete and tastemaker, and a good friend of the Countess de Greffuhle. As soon as Polignac heard that Winnaretta was back in the marriage market, he asked Montesquiou to go to de Greffuhle and propose him as a potential husband. As Winnaretta was rich, liked girls, and was becoming a social outcast, and Edmond was broke, liked boys, and was a fully recognized French grandee, the countess saw a perfect match of convenience. Edmond was highly acceptable outside the bedroom and was a composer to boot, and Winnaretta could promote him through her music salon, just as she promoted Jean Francaix, Igor Markevitch, Darius Milhaud, Francis Poulenc, Erik Satie, Henri Sauget, Igor Stravinsky, Germaine Tailleferre, Kurt Weill, Gabriel Fauré, and Nadia Boulanger, who later became her musical director.

In 1900, to avoid the crush of the opening of the World's Fair the Polignacs went to Venice with Marcel Proust, Proust's mother, Reynaldo Hahn, the poet Henri Régnier, and the Princess de Caraman Chimay. They cruised on the Grand Canal while quite theoretically discussing which palace they would most want to own. The next day, sitting on the balcony of the Palazzo Barbaro with the Curtises, who were cousins of John Singer Sargent and the palace's owners, Edmond de Polignac admired the Palazzo Contarini directly opposite, which was reputed to have once belonged to Desdemona. It had an enormous marble

facade embellished with Lombard motifs, and an evocative Romantic look. Polignac said, in his quiet way, "Ah! That is the place to live in, and we must manage to get it in one way or another." Winnaretta was taken aback, because Edmond was modest and never asked for anything. So, out she went, found a real estate agent and bought it for him as a birthday present. The magnificent palace became known as the Palazzo Contarini Polignac and is referred to sometimes today by the French as the Palais Decazes, since it later passed from the heirless Polignacs to the son of Winnaretta's sister Belle Blanche.

Wherever Winnaretta resided became the center of Europe's musical life. And the extraordinary performers and composers who were part of her studio on the rue Cortambert came to stay with and play for the Polignacs in Venice every summer. We know that Ignace Paderewski and Fritz Kreisler played concerts for Winnaretta and her houseguests in the palace, and that Nellie Melba, Luisa Tetrazzini, and Enrico Caruso sang in the Polignac salon over-looking the Grand Canal. There was no shortage of singers, as the Fenice put on many operas in the summer months, and all great artists considered performing for Winnaretta an honor that would advance their careers. Arthur Rubinstein also frequented the Polignacs' home and gave splendid concerts there, as did Vladimir Horowitz, who came with his wife, Wanda, her father, Arturo Toscanini—who cooked pasta in the vast kitchen—and the maestro's other daughter, Wally, the queen of La Scala. The Polignacs' next-door neighbor at the Palazzo Dario was the bisexual Augustine Bulteau, who had a remarkable collection of Renaissance and baroque musical instruments and cultivated quite a large circle of artists and writers into which the Polignacs fit very easily. Winnaretta painted a great deal, and she became the linchpin of the festival of the International Society for Contemporary Music, where Igor Stravinsky gave recitals of his most recent work. Most days, Winnaretta's gondola awaited new guests at the railroad station, and the happy musical groups would go out to the Lido, have coffee on the Piazza, visit the nearby Accademia and Salute, attend concerts, operas, and parties, eat well, make music together, and sightsee on the mainland. Isadora Duncan, who was the mistress of Winnaretta's playboy brother, Paris Singer, also frequented the Polignacs. And Winnaretta would spend quiet, discreet times off-season with her lady lovers, including Violet Trefusis.

Marchesa Casati

It is no wonder that Venice has always attracted eccentrics. What better home for a sensitive, wounded, or unaccepted soul than a place purposely cut off from the rest of the world? Where else other than this city built on stilts can one hide behind a mask and devote oneself to art and living? Where but Venice does one not need to conform to established mores? It was Thomas Mann's distinguished, aging von Aschenbach, in *Death in Venice* who escaped a community of Protestant, God fearing Hansa burghers as he pursued the beautiful Tadzio along the beaches of the Lido or the back canals of the city. Who would be interested in a deviate in a place where everything deviates from the norm? In Venice, oddballs are appreciated, not ostracized; they can seek a society of fellow eccentrics and be welcomed by the locals, the most balanced of whom are also seeking an escape.

Among the eccentrics, there have always been a few very rich, very spoiled, pleasure-loving exhibitionists who were seduced by the lavish celebrations, processions, and parties that once reflected the richest republic in Europe. There have always been decadent souls who contributed an exotic flavor to Venetian life, and whose reputation lives on. The most perfect example is the Marchesa Luisa Casati, referred to in Venice as La Casati.

On warm summer nights, she could be seen walking under the arcades of the Piazza San Marco, her face an impasto of white powder, her eyes blackened by great patches of kohl, and her hair dyed vermilion. As often as not, she was stark naked under a fur or velvet cloak, walking proudly behind two leopards that she guarded on dangerously long leashes. On less dramatic appearances, white Dalmatians, who otherwise lounged in the garden of her palace, replaced the large cats. La Casati was a great patron of the arts and she

The Marchesa Luisa Casati by Adolph de Meyer in 1912.

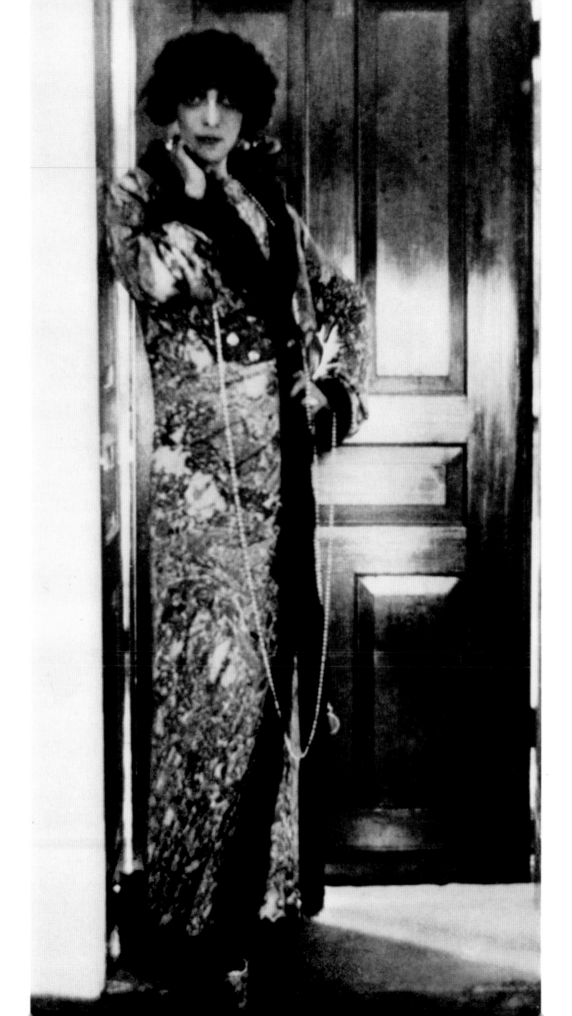

Left: La Casati with her leopard, about 1912.
Center: La Casati in a gondola with her greyhounds, about 1912.

threw some of the most extravagant parties in Venice. Rich in the extreme, La Casati inherited her fortune from her father, Alberto Amman, an Italian cotton king. When her parents died young, Luisa, along with her sister, Francesca, became one of the richest girls in Italy. Young and wealthy, Luisa Amman soon found herself married to the Marchese Camillo Casati, a member of Milan's high society, which included the Viscontis and Sforzas, whose lineage dates back to the Renaissance.

As a newlywed, she spent her days in museums, reading poetry and meeting intellectuals. It was an encounter in 1903 with the Italian writer Gabriele D'Annunzio that changed her life. Dashing, famous, and surrounded with the brightest lights of Italy's cultural life, which then revolved around symbolism and futurism, d'Annunzio made for a great lover. There was an electricity between them that made her marriage to a proper aristocrat, busy with horses and clubs, seem a total waste of time. It was at this time that La Casati transformed herself from a pretty and well-kept Milanese society girl to a mad-looking witch.

Thanks to Baroness Ernesta Stern, Luisa learned that the Palazzo Venier dei Leoni, in the *sestiere* of Dorsoduro, was for sale. On its site was once a large

Right: La Casati in costume as a white harlequin conceived by Léon Bakst in 1913.

palace that the Veniers knocked down in 1749 and planned to replace with something far more spectacular, to be the most sensational palace in Venice. Plans were made, the first floor built, the facade sheathed in Istrian marble, and a pair of lions placed on the Grand Canal, and then the owners lost all their money. The Marchesa Casati bought the palace in 1910 and spent a fortune restoring and decorating it. She filled the garden with peacocks and white doves, and hired an immense black man called Garbi, to lend an exotic touch to her receptions. She bought a beautiful gondola and was soon steered through the canals of Venice by two liveried gondoliers in traditional knee breeches and gold-buckled shoes. On the prow stood her two leopards, taking in the evening air. Also in her collection of exotica were monkeys, parrots, and a boa constrictor that the marchesa would wrap around her neck. This odd bestiary, led through Venice's smelly canals by such an extraordinary creature as Casati, evoked cheers of "brava." Shunning traditional dresses made of Venetian lace and the elegant gowns of Poiret, Casati embraced Mariano Fortuny's more modern creations in exotic silks and pressed velvet.

With her setting in place, it was now time for La Casati to host her first costume party, which would astonish the stuffy Venetian aristocracy, as well

as the haut monde that flocked to Venice from all over Europe and Russia during the high season in August and September. The festivities started with a sumptuous costume ball in La Casati's palace, which was decorated with handsome young men who were practically naked and covered with gold paint. (Nobody considered that the body paint would not permit their pores to breath, and many men nearly died.) When her residence could no longer hold the crowds who came to her parties, Casati took over the Piazza San Marco for the night for the Pietro Longhi ball with two hundred torch-bearing lackeys dressed in velvet and powdered wigs, and she decorated it with large swatches of Fortuny silk. Soon an invitation to the Palazzo Venier dei Leoni was the top prize on the international social calendar, and the entire Gotha passed through its doors.

When the Venetian season ended in October, Luisa Casati would travel between Rome, St. Moritz, and Paris. She was crucial in launching St. Moritz as a chic resort, and standing in for her gondola was a horse-drawn sleigh on which she lounged, swathed in fur; the cold-hating leopards stayed in Venice. And when she arrived at her suite in the Ritz on the Place Vendôme, everyone in Paris was at her beck and call, including Olivier, the renowned maître d'hôtel of Marcel Proust, who sent out the bellboy to bring back live pigeons for her boa constrictor. And such was her success that La Casati decided to buy a marble palace outside Paris, but she had barely decorated it with her signature panther skins and exotic furniture when World War broke out. The fun was over, but the spoiled—and perhaps now slightly mad—Marchesa didn't realize it. She organized a housewarming at her Palais Rose and instead of cheering Venetians, she and her guests were greeted by embittered Frenchmen throwing rotten tomatoes. *Le tout Paris* was not amused and dropped La Casati as quickly as they picked her up, and as soon as she ran out of money.

Quite antithetical to her Venetian palace, Casati's final abode was a single room in Knightsbridge overlooking Harrods, with a balcony she shared with three impoverished neighbors. One of the last calls she made was to a friend. "I have a few shillings left," said the ever-hospitable Casati. "Would you like to join me in a bottle of wine or a taxi ride?" That is style.

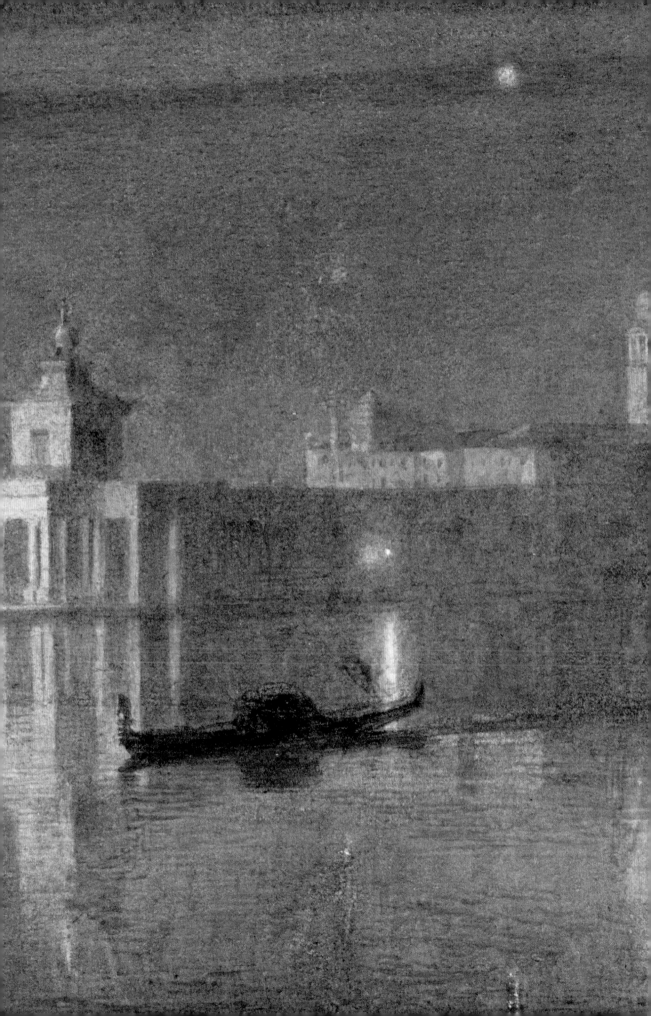

Peggy Guggenheim

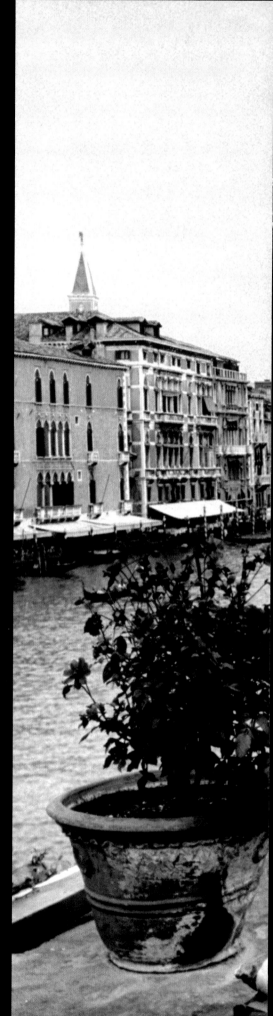

Some people become famous because they choose talented friends and follow their advice. Others are sought out because they themselves have become famous. Peggy Guggenheim started as the former and finished as the latter. When she first invited me to dinner on Thanksgiving in 1958, Peggy had owned the legendary Palazzo Venier dei Leoni for only seven years. She had just opened her collection to the public for three days a week and engaged a young and dashing Venetian aristocrat, Count Paolo Barozzi, to be her curator. This job involved putting out a bowl to collect the entrance fee, picking it up if Peggy didn't get there first, printing an occasional brochure for visitors, feeding the Lhasas, and pouring coffee at the sort of party to which I was invited.

At her dinner party, there was a lot of drinking and a menu of turkey with chocolate sauce, which sounds more surrealist than it was since it's simply a variation of chicken mole that she

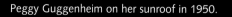

Peggy Guggenheim on her sunroof in 1950.

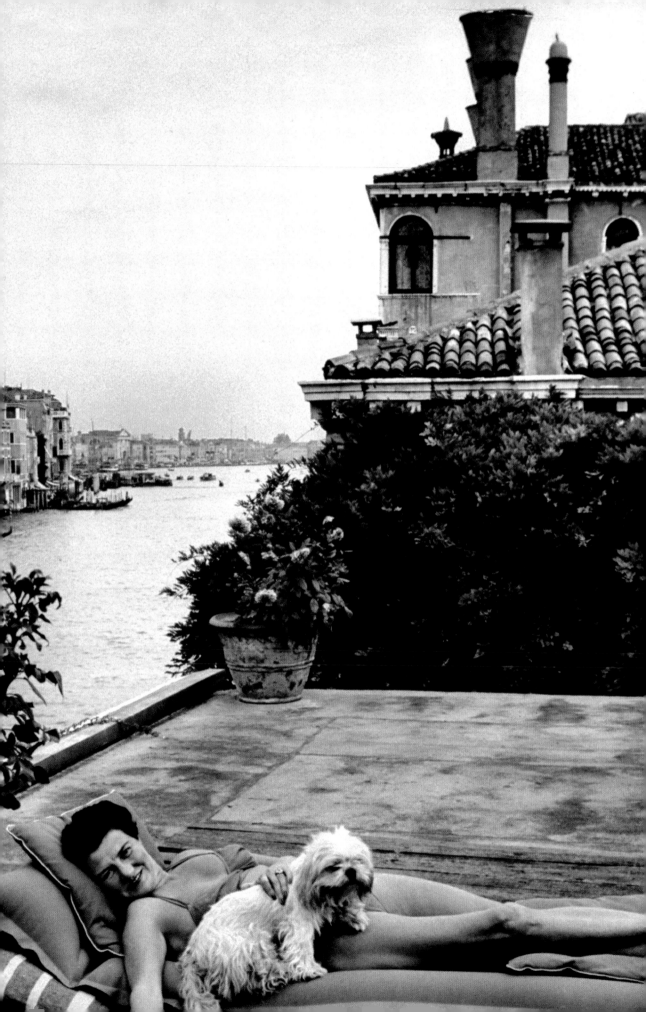

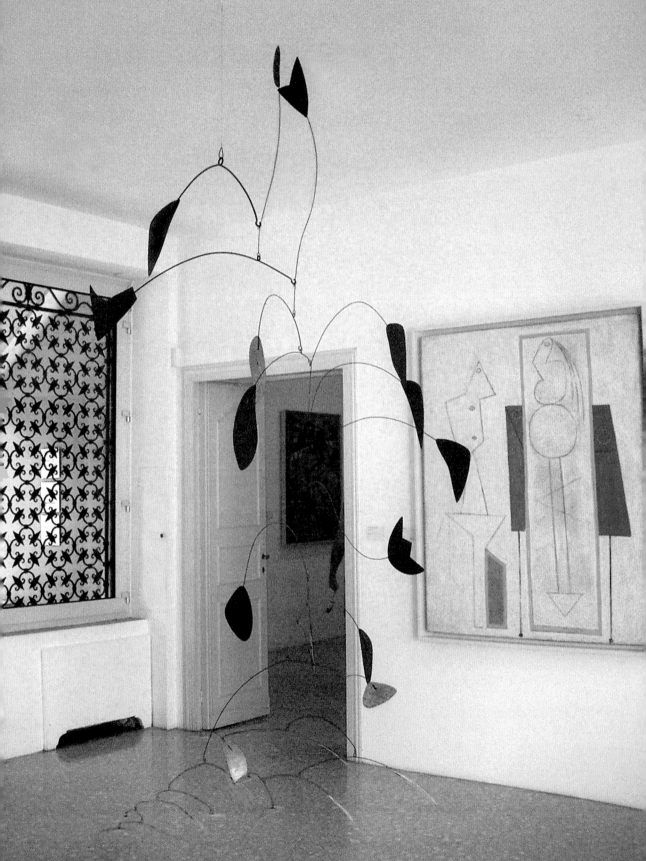

Mobile by Calder and *L'Atelier* by Pablo Picasso
at the Peggy Guggenheim museum.

Right: Peggy Guggenheim puts up a mobile
by Calder, in the Greek pavilion,
just before the opening of the twenty-fourth
Art Biennale of Venice, in 1948.

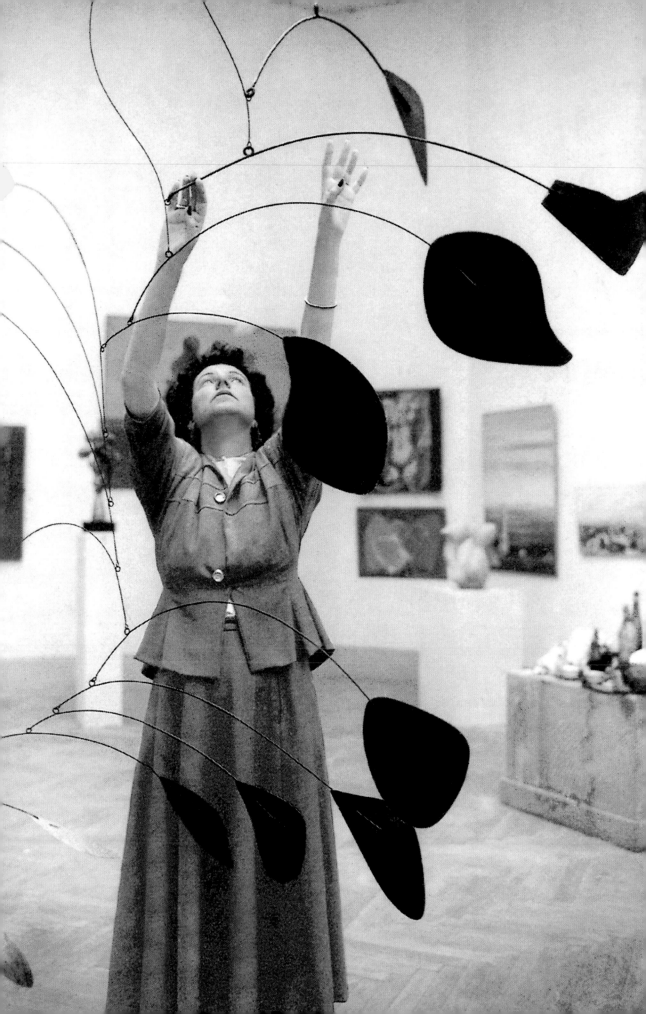

probably learned of at one of those Mexican resorts where Americans drink themselves to death.

Peggy collected all the foreign strays in Venice, of which there were few at the time. Among her gents were two Cubans who lived at the Palazzo Dario next door. As a side note, I believe that one eventually murdered the other; the Dario was as identified with tragedy as the Venier dei Leoni was linked with eccentrics, a category to which Peggy surely belonged.

Most of her friends were chased out of Venice by a homophobic, puritanical mayor who also insisted that she remove the erect penis of the nearly life-size bronze Marino Marini boy on a horse that adorned her water gate. To avert the mayor's ruling, Peggy had one made that could be screwed on and off, depending on whether a cardinal was cruising the Grand Canal. Once she greeted the writer Somerset Maugham with it in her palm, shouting triumphantly, "I've got you at last!"

At the Thanksgiving dinner, as the night went on, the alcohol eventually got to her, and we had to put Peggy to bed under that rather ugly Calder curlicue wall decoration that still hangs in the museum. Indeed, I felt privileged to be invited and was asked back several times. Peggy Guggenheim could be a good egg and a nice lady, particularly if you weren't related to her. Pegeen, her daughter, and Sinbad, her son, must have broken the *Guinness Book of World Records* for the maximum number of suicide attempts in any family, so we must presume that Peggy wasn't a great mom. But Peggy had a distinguished background and was the very top of "Our Crowd." One of her grandfathers was James Seligman, the founder of a great merchant banking dynasty, and the other was Meyer Guggenheim, who made his fortune in prospecting and mining. Her father, Benjamin, went down on the *Titanic* as a young man, demonstrating both his courage, and penchant for the first-class life. He had always lived very well and probably spent too much, and it was a shock to Peggy when he died.

By the time her trust fund was set up, Peggy was to receive $22,500 per year. Eventually, that figure grew to $35,000 a year, with $40,000 as the largest lump sum she ever received, which gave her the idea of doing something in the arts. When she was actively collecting, which was during two brief periods,

she limited herself to an annual budget of $125 a year for dresses. Considering those figures, what is on view in her palazzo today is truly impressive, as it is worth well over a billion dollars. Peggy was as interested in money as her ancestors, and they would be proud of what she accomplished. Admittedly, the paintings now in the museum were once dirt cheap, but you had to be smart enough, or lucky enough, to buy them.

Peggy soon befriended Marcel Duchamp, Max Ernst, Sir Herbert Read, Clement Greenberg, and others who all played important roles in her collecting. Duchamp gave Peggy a crash course in the offshoots of surrealism and Dada and, as a result, she opened a gallery on Cork Street in London called Guggenheim Jeune, a pun on Paris' renovated Bernheim-Jeune gallery. Duchamp suggested and arranged for an exhibit of contemporary sculpture, including works by Alexander Calder, Duchamp Villon, and Jean Arp. In a nutshell, Peggy sponsored unknown artists who were to become legends, purchasing their work and selling them in her gallery; the paintings that did not sell became part of her collection.

As Hitler's presence in Western Europe intensified, Peggy planned her return to New York City and asked the Louvre to store her collection for the duration of the war; they refused, deeming the works too modern. What they didn't consider worth saving, Peggy wrote in her memoirs, were "a Kandinsky, several Klees and Picabias, a cubist Braque, a Gris, a Leger, a Gleizes, a Marcoussis, a Delaunay, two futurists—a Severini and a Balla—a van Dongen, a "De Stijl" Mondrian. Among the surrealist paintings were those of Miró, Max Ernst, de Chirico, Tanguy, Dalí, Magritte, and Brauner." Peggy didn't ask the Louvre to store her sculptures, which included works by Brancusi, Lipchitz, Laurens, Pevsner Giacometti, Moore, and Arp. Quite simply, in just three years of dealing and collecting, from 1937 to 1940, Peggy Guggenheim had put together, for very little money, most of the works that people rush to see today at the Palazzo Venier dei Leoni. And her collection was far from finished.

Peggy brought Max Ernst to New York and married him because, as she said, he was a good painter, famous, and beautiful. Their life together was often stormy, a state not helped when he painted her as a standing centaur

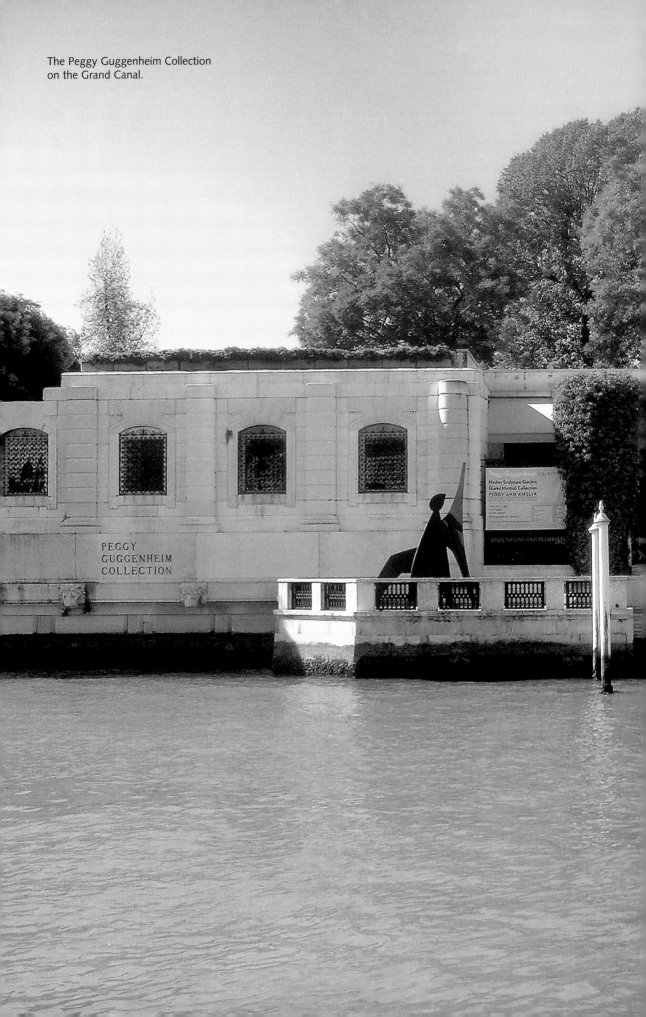

The Peggy Guggenheim Collection
on the Grand Canal.

with a monstrous horse's head and her own bare belly, a work on exhibit today at the Venice Guggenheim. Many surrealists sought refuge in the United States during the war and, as Max Ernst's wife and the only one in the group with money, Peggy's apartment became their rallying point. There were endless parties in the flat, at which European surrealists mixed with American WPA artists, launching what became known as Abstract Expressionism, the movement that made New York City, instead of occupied Paris, the epicenter of modern art.

Today everyone knows Peggy Guggenheim as the one who "discovered" Jackson Pollock. She put him under an exclusive contract—the only artist to ever have that arrangement with her—and gave him a one-man show in 1943: he got $150 per month and she got all his paintings. And in 1947, at the very height of her New York success, Peggy folded her tent and moved to Venice, thus ending the second and last short period of her collecting.

Like many expatriates, she first lived at the Palazzo Barbaro. In 1948, she bought the Palazzo Venier dei Leoni for a pittance, painted the barber poles on the canal her signature turquoise and white, dressed her gondoliers to match, and was rowed through Venice every day. A visit to Peggy's palace was now a must for anyone interested in modern art—or simply in boasting that they had seen her collection. She was called La Dogaressa, the new queen of Venice, wore outlandish sunglasses shaped like butterflies, and was cheered by the crowds, much like the Marchesa Casati.

When Peggy Guggenheim died, everyone wanted to inherit her collection; Uncle Solomon for his Guggenheim museum, Herbert Read for the Tate, and, naturally, the Soprintendenza dei Belli Arti for Venice. In the end, the collection remained in the Grand Canal palace and was controlled by a separate foundation. As could be expected, every trace of Peggy's way of life was swept away; the Lhasas were buried in the garden, as were her ashes. The Palazzo is now home to fundraising galas for endless causes—above all for the Guggenheim museums—and the casual living rooms have been converted to sterile galleries on par with any international museum. All those who knew Peggy have a secret wish that she would come back and raise hell.

Peggy Guggenheim and her gondolier in front of the Palazzo Venier dei Leoni in 1968.

Codognato

The euphoria of being in Venice, the luxury of its hotels, the palpable romance, and the sheer visual beauty of the surrounding city all create a devil-may-care attitude that is highly propitious to spending lots of money. It's as if reality had receded and tomorrow didn't matter. Euphoric from the city's beauty, and with time on their hands, anyone who visits Venice is particularly tempted by its luxury shops. That is why there are so many in such a small city, particularly jewelers.

The best, and most engaging, are the shops that specialize in such Venetian specialties as blackamoors, cameos, carved semiprecious stones mounted in enamel, *pietre dure* boxes and baroque-inspired silver objects. For the less well heeled, the small, colorful jewelry boutiques on the Rialto are the places to go—that is, after all, where Shakespeare's legendary Shylock hung around and traded. But the finest jewelers are around the Piazza San Marco. Many deal in the Revivalist jewelry that swept the Italian trade at the

Le *Salotto Veneziano*, the salon where the Italian jeweler Attilio Codognato receives his clients.

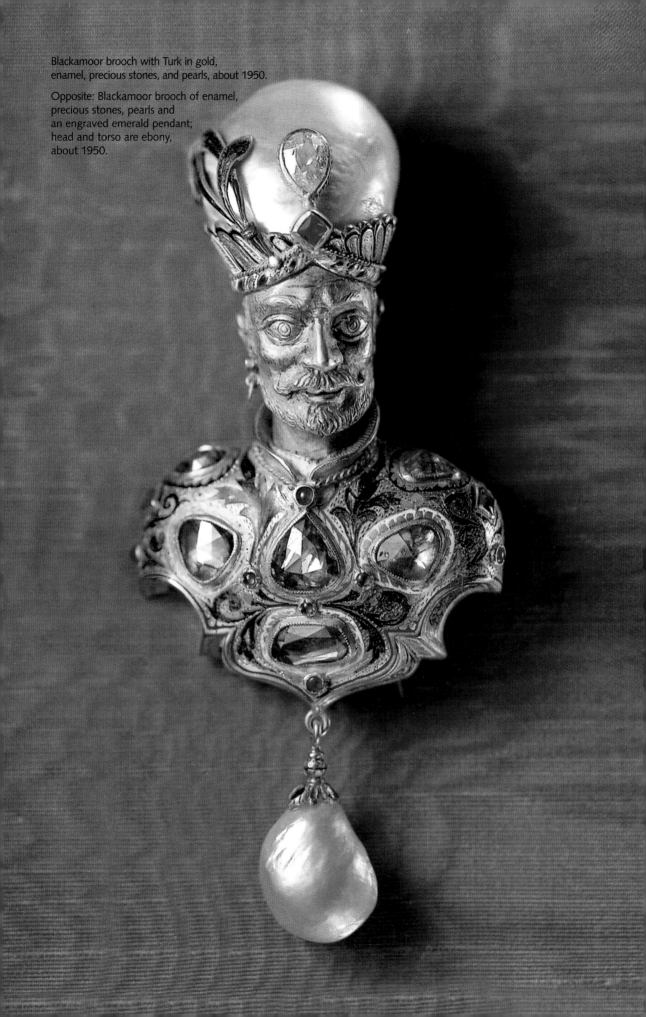

Blackamoor brooch with Turk in gold,
enamel, precious stones, and pearls, about 1950.

Opposite: Blackamoor brooch of enamel,
precious stones, pearls and
an engraved emerald pendant;
head and torso are ebony,
about 1950.

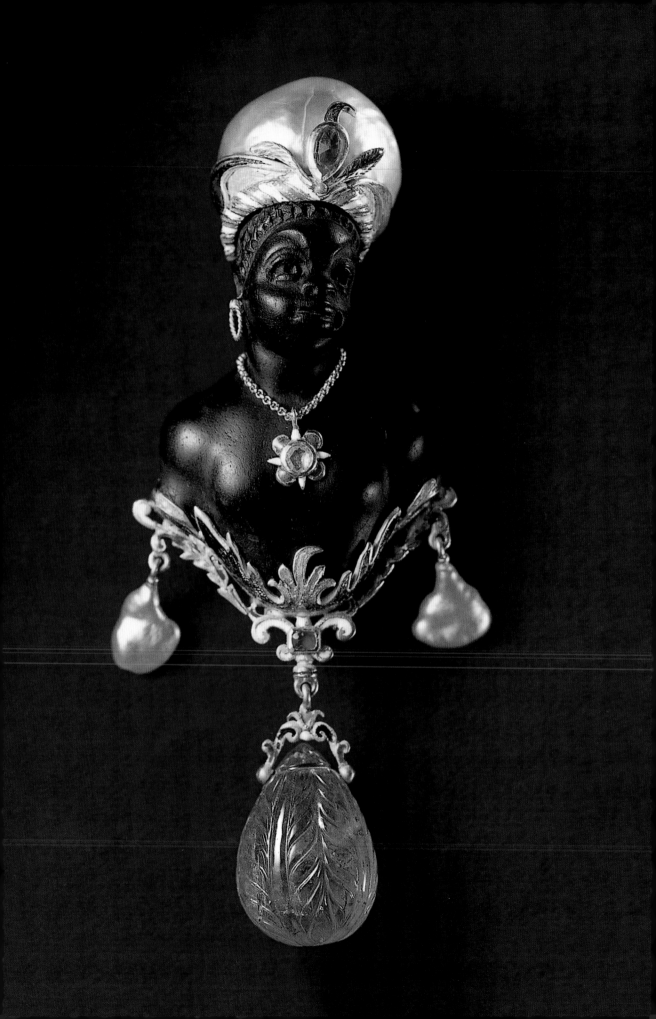

end of the nineteenth century after an Etruscan gold hoard was discovered by the Cavaliere Fontana and exhibited in Rome. The leading Revivalist jewelers were Castellani in Rome and Giuliano in Naples, and they had a great influence on the French master jewelers Henri Vever and Georges Fouquet. Castellani and Giuliano made jewels that looked as if they had just come out of a tomb, and then created variations with their personal style. The fabulous jewelry that arrived in Venice from Constantinople, such as the cloisonné enamels in the Pala d'Oro, was also an inspiration.

Blackamoors carved in ebony, mounted in gold and studded with paved diamonds, precious and semiprecious stones, pearls and practically every stone in the jeweler's repertory have been particularly popular since the end of the last century and are sought out by the world's best-dressed women. They are take-offs on Renaissance jewels, with more than a bit of fantasy.

The most fashionable and very best place for Venetian baubles is Codognato, equidistant between the Piazza and Harry's Bar. Its interior looks so much like a private house that no ordinary tourist would dare to venture inside, and in any case, the doors are locked. The treasures in the window are a clear indication that it's not a place for ordinary people. Guarded inside and shown on two baroque desks to millionaires perched on delicate Louis XV chairs are jewels far too valuable to flaunt before a milling crowd of tourists.

The business was founded in 1844 by Simeone Codognato and by 1866, he opened his shop at the current address and began to design his own pieces. After Simeone's death, his son Attilio took over and started making Revivalist jewelry. Unlike other jewelers, the Codognatos didn't follow fashion trends, and they built up an extraordinarily faithful clientele. Today Attilio Codognato, the great-grandson of its founder, runs the business. He is also the president of the Venice Bienalle and a major collector of modern and contemporary art; his palace near the Rialto is as close to a private museum as any collector will get. Despite his important responsibilities, Attilio can be found most hours of the day behind one of the baroque desks, showing jewelry, talking to friends, and politely receiving newcomers who may never buy anything. What he pulls out of the drawers behind him, and what his assistants bring from a back office offers constant surprise. He is one of the truly *grandi signori* of Venice.

The *Madona Nicopeia*, Byzantine icon, 10th-11th century, Basilica of San Marco.

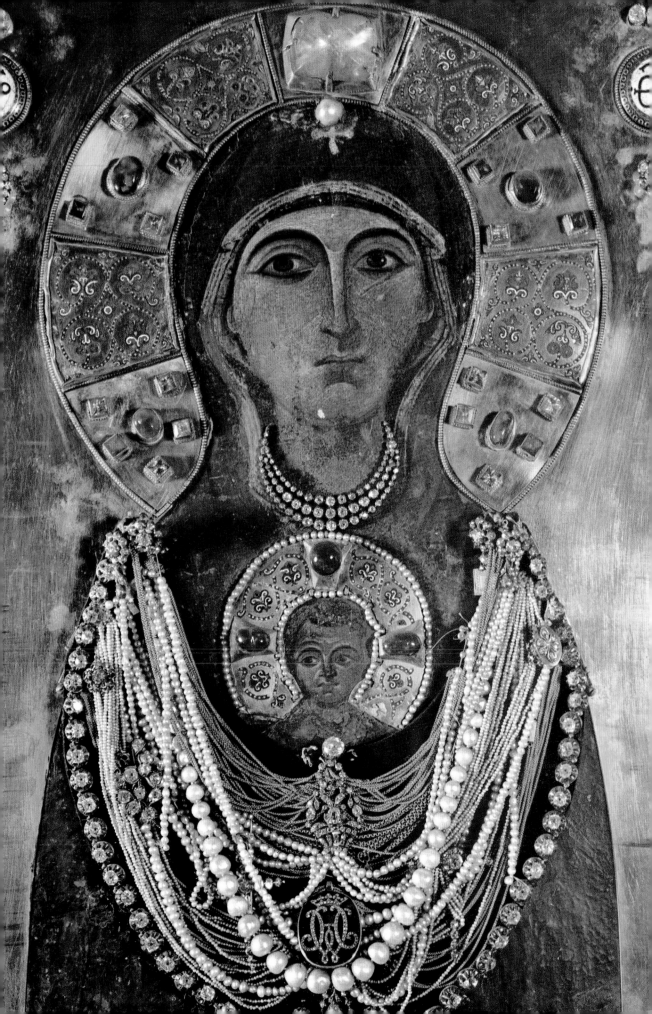

Balls &
Carnival

Venetians have always loved festivities, processions, open-air concerts and parading around in masks—for some, in the hope of engaging in anonymous sex. Nobody does more honor to Carnival than the Venetians, and the society ball inevitably became part of the local scene, particularly after World War II. For that matter, Venetian balls around the world have long been considered chic among the rich, as epitomized by George Kessler's redecorating the ballroom of London's Savoy Hotel in 1905, bringing in a gondola, dressing up singers as serenading gondoliers, and asking everyone to wear a mask.

When the subject of balls comes up in Venice, everybody still talks about the party arranged by the Mexican silver millionaire Carlos (Charlie) de Beistegui in 1951. The truth is that most of the guests were French, there was very little dancing, nobody had a terribly good time, and everybody spent a fortune on costumes that were nearly impossible to move in. French high society has always

Palazzo Volpi during a ball given by Conte Giovanni
Volpi di Misurata for the 18th birthday of his niece,
Donna Olimpia Aldobrandini, in 1973.

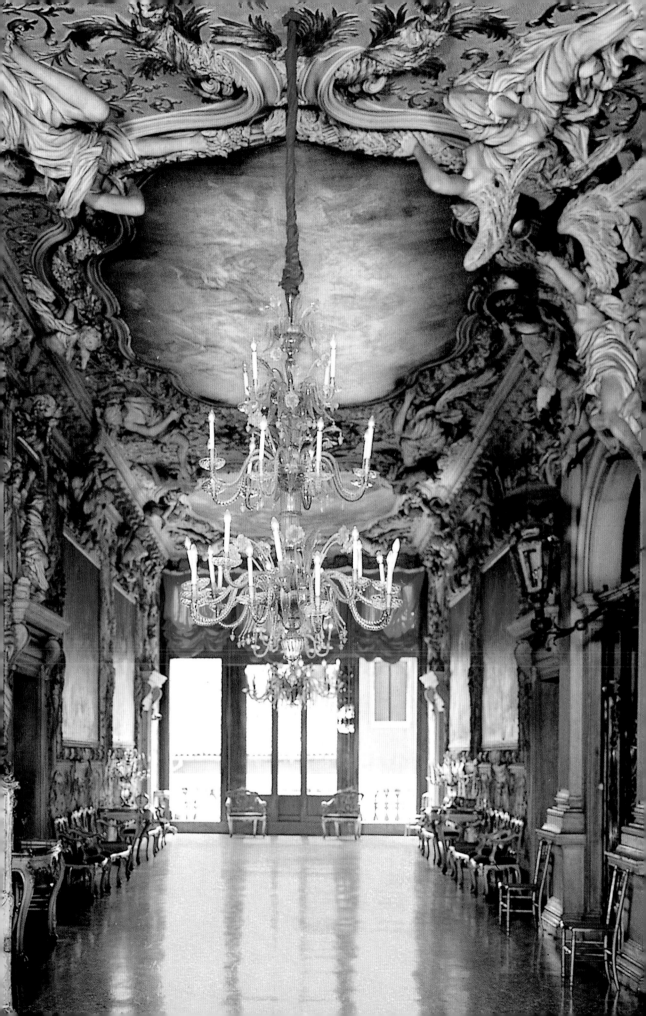

loved masquerade parties, and at the court of Versailles there were endless divertissements of this sort on a theme, for which Molière wrote plays, Lully composed music, and the Sun King's architects tamed the landscape. This obsession with dressing up continued during the first and second empires and during the Restoration, where we have records of "bals travestis et tableaux vivants" in the form of watercolors by Eugène Lami. During the early twentieth century, Count Boni de Castellane, who had married Anna Gould, the daughter of a disreputable and very rich American railroad king who was dying to pay his way into high society Paris, organized parties with the guests making up *tableaux vivants* on the front lawn of his marble-sheathed Palais Rose.

In 1911 the couturier Paul Poiret held a Thousand and One Nights party, and the genial Etienne de Beaumont and his wife, Edith, endlessly invited *le tout Paris* to come dressed for balls with themes such as games, the sea, French colonies, famous paintings, kings and queens, and Racine among others. The host invited the most famous artists of the day—Picasso, Cocteau, Braque, and Derain—to create a setting, and no sooner had the invitation arrived, which was beautifully designed around the appropriate theme, than the phones began to ring. Guests would group their entrances, or *grandes entrées*, and talk about which of the great designers or painters would work on their costumes. Coco Chanel, Paul Poiret, and Cristobal de Balenciaga were some of the designers who labored for hours in the closest possible collaboration with their clients on every detail, and the competitive atmosphere to outshine one's peers was ferocious. Everything was kept as secret as a battle campaign, and when the host received details of the *tableaux* from his guests, he stage-managed everybody, sequencing arrival times and the order of everyone's entrance. Afterwards, there was a light supper and a bit of music, and then everyone went home and discussed the ball in every detail for months.

Other famous Paris balls included the Pecci Blunt White Ball, at which Man Ray projected a movie onto the moving figure; (the White Ball also inspired the men's white dinner jacket); the Country Ball, organized by Baron Nicolas de Gunzburg and Elsa Maxwell in 1931; and a Second Empire Ball, organized by Prince and Princess Jean-Louis de Faucigny Lucinge. Amazingly, this went on in Paris right up to World War II, when everything came to a halt.

Preceding double-page: A ball given by Count Giovanni Volpi Di Misurata in 1963 (left) and the interior of the Palazzo Albrizzi (right).
Opposite: Haute couture shoot in the Villa Caldogno for *Vogue*, March 1956.

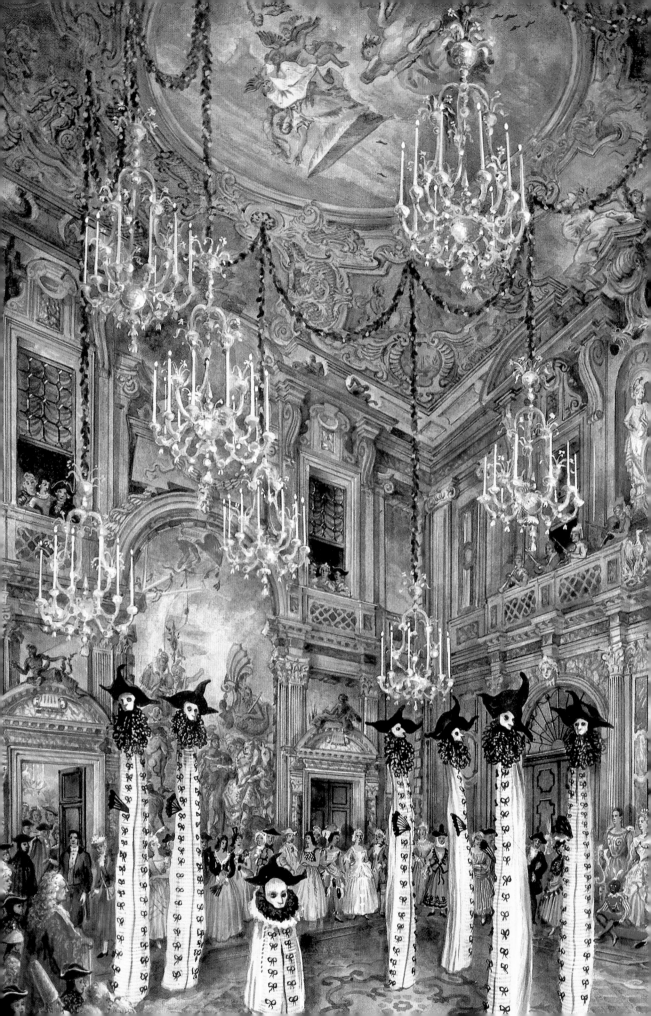

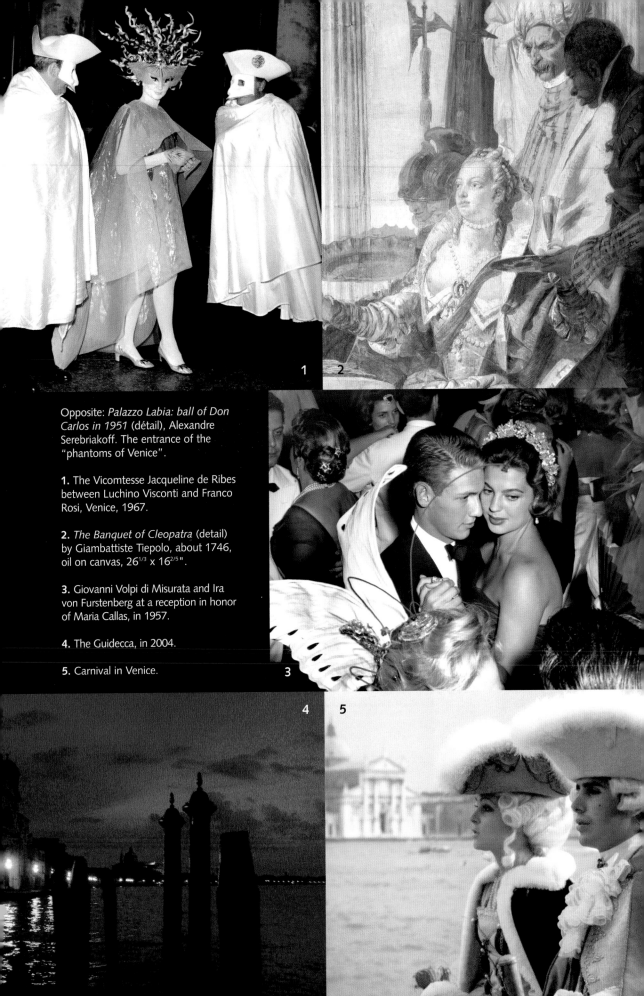

Opposite: *Palazzo Labia: ball of Don Carlos in 1951* (détail), Alexandre Serebriakoff. The entrance of the "phantoms of Venice".

1. The Vicomtesse Jacqueline de Ribes between Luchino Visconti and Franco Rosi, Venice, 1967.

2. *The Banquet of Cleopatra* (detail) by Giambattiste Tiepolo, about 1746, oil on canvas, $26^{1/3}$ x $16^{2/5}$ ".

3. Giovanni Volpi di Misurata and Ira von Furstenberg at a reception in honor of Maria Callas, in 1957.

4. The Guidecca, in 2004.

5. Carnival in Venice.

The Secret Denunciation (detail), Vincenzo Giacomelli, about 1880, proof on albuminized paper.

It was the renowned Beistegui ball that marked the emergence of European society from the terrible war. The French recovered from quarreling about who did or did not collaborate with the Nazis, Christian Dior launched the New Look, the couture houses started up again, and everybody was dying for a party. Beistegui had spent the war years building his château at Groussay, outside of Paris, and studding its garden with pavilions designed by Emilio Terry. In 1950, he bought the magnificent Palazzo Labbia in Venice for a song, restored and redecorated it, and decided to give a house-warming in the form of a prewar ball. The guests dressed up as *tableaux vivants* and were presented in the main salon of the palace where Giambattista Tiepolo had painted his masterpiece *The Banquet of Cleopatra.* All of European society floated down the Grand Canal in their costumes, including the couturier Jacques Fath, dressed as the Sun King in white and gold, his breeches so tightly cut that he couldn't sit down. Also floating down were Elizabeth de Breteuil-Chachvadze as the Empress Catherine of Russia, the Chilean art collector Arturo Lopez, and his wife, Patricia, wearing costumes inspired by a tapestry entitled *The Progress of the Emperor of China,* and Lady Diana Cooper and the Baron de Cabrol as Anthony and Cleopatra in costumes designed by Schiaparelli. Dressed in red silk, Beistegui, on stilts, greeted everybody from the top of the staircase in the

habit of a procurator of the Venetian Republic, and the entertainment consist-
ed of a ballet organized by the Marquis de Cuevas, with Venetian firemen
standing on stilts and dressed in Carnival costumes designed by Salvador Dalí.
A supper and fireworks that lit up the entire city completed this fantasy
evening. Those who weren't invited but had arrived in Venice with a slight
hope of getting in were suicidal, and people talked about the ball for decades.

It was Countess Lily Volpi, the wife of Giuseppe Volpi, however, who start-
ed giving proper balls in Venice, where people didn't have to spend a fortune
on a costume for the night (although most ladies felt obliged to order a new
haute couture dress), where they didn't have to worry about who was going to
outdo their *tableau vivant*, where young people could really dance to the music
of a good band and revive their energy with an ongoing and delicious buffet and
lots of champagne. Countess Volpi took her guest list very seriously, which was
what made everybody want to be included, and she filled the city with her
friends from all over the world. Venice became one big house party. You could
not go for a walk without running into fifty friends, lunch and dinner parties
abounded and nearly everybody was invited to a palace to dine before the ball,
which started at 11 p.m. Fortunately, her son Giovanni continued the tradition.

There have, of course, been many other private balls: Earl Blackwell gave

one in the Ca' Rezzonico as did Elsa Maxwell. And there have been splendid fundraising parties by committees that pay for Venetian restorations, the best ones organized by Venetian Heritage at the Brandolini palace. Balls are often better in anticipation than in reality. Kitty Miller, the wife of the Broadway producer Gilbert Miller and the daughter of Wall Street tycoon Jules Bache, once quipped during Elsa Maxwell's party in Venice, "All these balls and no men!"

If you want to go to a ball in Venice today instead of reading about balls for dinosaurs fifty years ago, book yourself a room in Venice during Carnival. The mid-winter celebration dates back to antiquity and has always been linked to fertility rites, sexual activity, and Spring. Carnival is an event limited to Catholic countries and starts exactly four weeks before Shrove Tuesday, or Mardi Gras, which marks the end of this Bacchanalian fiesta, after which Catholics have their foreheads anointed with ashes and go on a frugal diet until Easter Sunday. Carnival's most famous manifestations are in Rio de Janeiro, where men and women samba half-naked through the crowded streets, and in Venice, where everybody shivers in winter's cold and rain, disguised in masks and costumes. In the eighteenth century, the traditional men's costume, or *bautta*, was composed of a black, silk hood and a lace-decorated cloak known as a *tabarro*, along with a three-cornered hat and a papier mâché white mask. The women also wore masks as well as tight, bright-colored, busty dresses to turn on the men. Everybody cruised around, dancing and singing in the *campi*, palaces, and above all, in the *ridotti*. All these disguises were meant to dissolve strict class separations through anonymous sex.

When Venice faded as a powerful republic and became mainly a tourist center during the late nineteenth century, the celebration of Carnival went into decline. Hotels closed in October so there was nowhere for visitors to stay, and there were not enough locals to pay for the hoopla. It was only in 1980, after the hotels were encouraged to stay open most of the year, that the Venetian authorities thought of reviving Carnival, and creating a new money making opportunity. It took off immediately; people buy or make fantastic costumes; dances are organized; there are beauty contests for the best dressed people; balls are held on the Piazza; and the local aristocracy opens their palaces for masked parties that bring back all the beauty and excitement of the eighteenth century.

Carnival in Venice: costumes and extravaganza.

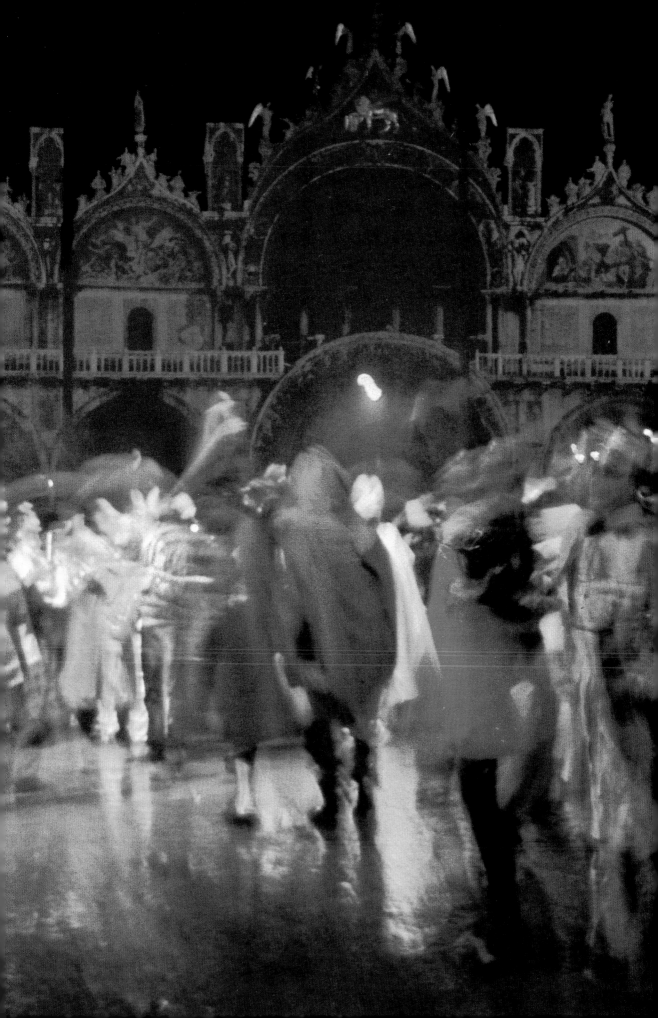

Harry's Bar

It was Giuseppe Cipriani who founded Harry's Bar in 1931 during the jazz age, when the American bar was in fashion. For parched Americans, who could only get their alcohol in speakeasies during the depressing days of Prohibition, drinking was a major occupation upon arrival in Europe. The first Harry's Bar—unrelated to the Venetian institution—was located in Paris at 5 rue Daunou, and to allow Americans to make their way there, daily ads of the Paris *Tribune* advised them to say *sank roo doonoo*. Giuseppe Cipriani, like any bar owner worth his salted peanuts, was very welcoming and made everybody feel at home at his establishment off the Piazza San Marco. His son, Arrigo Cipriani, now stands at the entrance to this world-famous destination— when he isn't somewhere across the globe overseeing what has become a restaurant empire. Arrigo is not above picking up a dirty plate, sweeping away a soiled tablecloth, or taking a lunch order from a head of state, movie star, American millionaire or someone he doesn't even know. His nervous green eyes dart around the room, checking that David Hockney's pitcher of white wine is full, that Countess Anna Maria Cicogna's favorite fluffy chocolate cake is on the way, and that Prince and Princess Michael of Kent (the prince looking like a resurrected Emperor Nicholas I) have their champagne in an ice-filled silver bucket. Next, Arrigo may stare down an unknown and badly dressed drunken tourist who is willing to spend $15 on a Bellini just to say that he went to Harry's Bar. Arrigo puts up with everybody because he remembers that it isn't high season at dinnertime every day of the year, and he knows that during the off-season every filled glass counts, no matter whose it is. If you get a reputation for being snotty, occupancy invariably goes down. Arrigo is as sprightly as he was fifty years ago and he

The window of Harry's Bar.

The window of Harry's Dolci.

remembers your name even if you haven't been to Venice in several years and have put on twenty pounds.

Being at Harry's is returning home, and like home, it never changes: there are still those tiny tables that make you feel as if your knees will soon reach your throat, the menu is always the same length with the same fish, mushroom risottos, creamy *paglia al fieno*, and *fegato alla veneziana*. Still being shown around are those tall, creamy white and dark chocolate cakes whose real destiny is to be heaved in the face of a Marx brother. The bony grissini are still as thin, the round puff pastry rolls are as dangerous as ever for one's arteries, and there never seems to be a limit on what you are able to drink—particularly if it is bubbly spumante in a crystal pitcher.

There is only one place to be at Harry's Bar, and that is the cramped downstairs, a sort of extension of the busy street, where you can see who enters and vice versa. As Harry's is everybody's first dinner or drinking stop upon arriving in Venice, you can instantly arrange your social life, know who is in town and who is exhibiting their work. This is the most compact dining space anywhere in the world; its white walls, dark wooden paneling and crowded galley—where middle-aged lady cooks with green shower caps on their graying locks

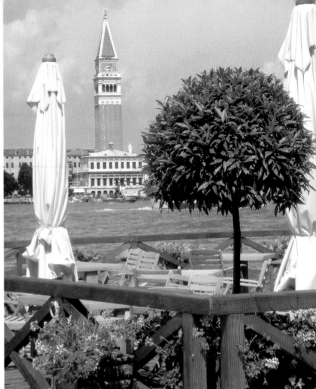

Arrigo Cipriani at the bar of Harry's Bar in Venice (left),
and the view from the restaurant Cips on the Giudecca (right).

resemble nurses about to scrub for an operation—recall an elegant and expensive sailing yacht, where every centimeter has been measured. The crew moves around silently, trained for emergencies and eager to satisfy every whim, friendly yet respectful to the passengers, and always guided by Captain Arrigo, even if he is giving instructions from one of his New York restaurants. Arrigo is the captain of many ships, including Harry's Dolci and Cips on the Giudecca, one of the best places imaginable for a quick pizza or pasta lunch, and the Locanda Cipriani in the lagoon for a country meal. There is a catering service that provides Harry's Bar food for the best private parties in the great palaces around town and can even put together a kosher dinner for a few hundred people in Jerusalem without a hiccup. And, of course, there is Harry's Bar in London and Harry Cipriani at the Sherry Netherland in New York, the Rainbow Room, Downtown Cipriani, and so on. Admittedly, there really aren't enough good cooks and solicitous waiters to keep up the Venetian standard everywhere, and dinner for four at the Venice restaurant could pay your own private chef for a month. That is unless you are a local baron, marchese, or member of the intellegentsia, in which case Arrrigo will bill you less than half of the prices listed on the menu!

Hotels de Luxe

Hotels de luxe are an endless subject of discussion, and each has its adherents. Every establishment has enjoyed its moment of glory, and many also suffer temporary declines. The standard of luxury at Venetian hotels is among the highest in the world, and strict rules imposed by the municipality govern how many stars a hotel receives and, consequently, how much it can charge. Room size, the ratio of staff to guests, the size of public areas, dining facilities, and quality of service all are part of a rating system as severe as that of the Michelin Guides. Like almost everywhere in the world, some are known for the quality of their rooms, others for their restaurants.

For the sheer luxury of its appointments, the Gritti takes the cake. This converted palace was inhabited by Ruskin before it was converted into a hotel that welcomed the likes of Hemingway and Stravinsky. Of all the luxury hotels, it is the richest in its antique furniture and eighteenth-century

The pool of the Hotel Cipriani, 2003.

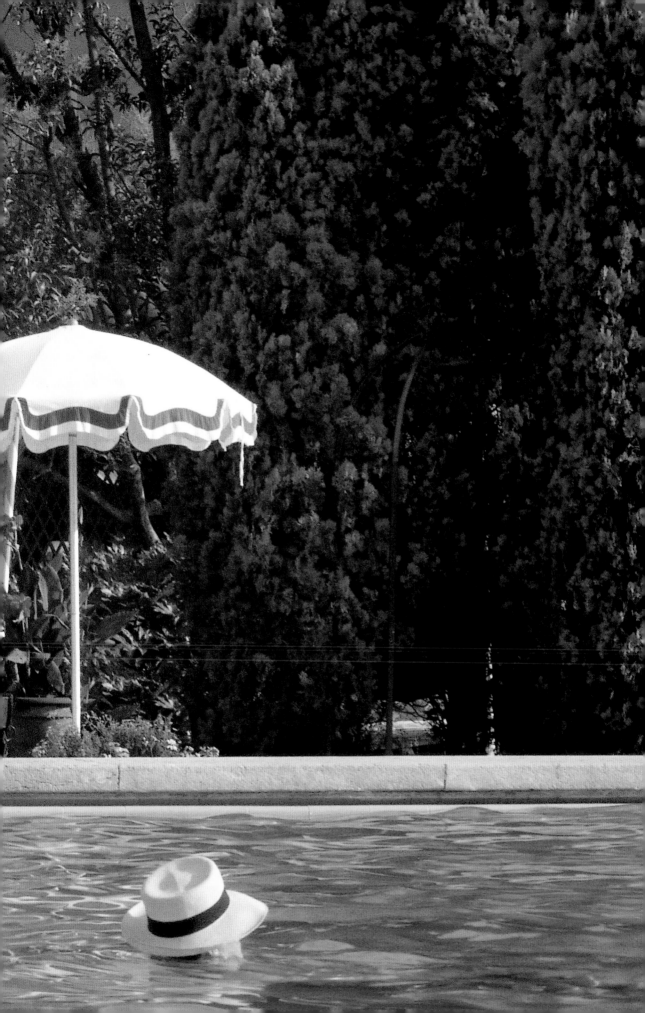

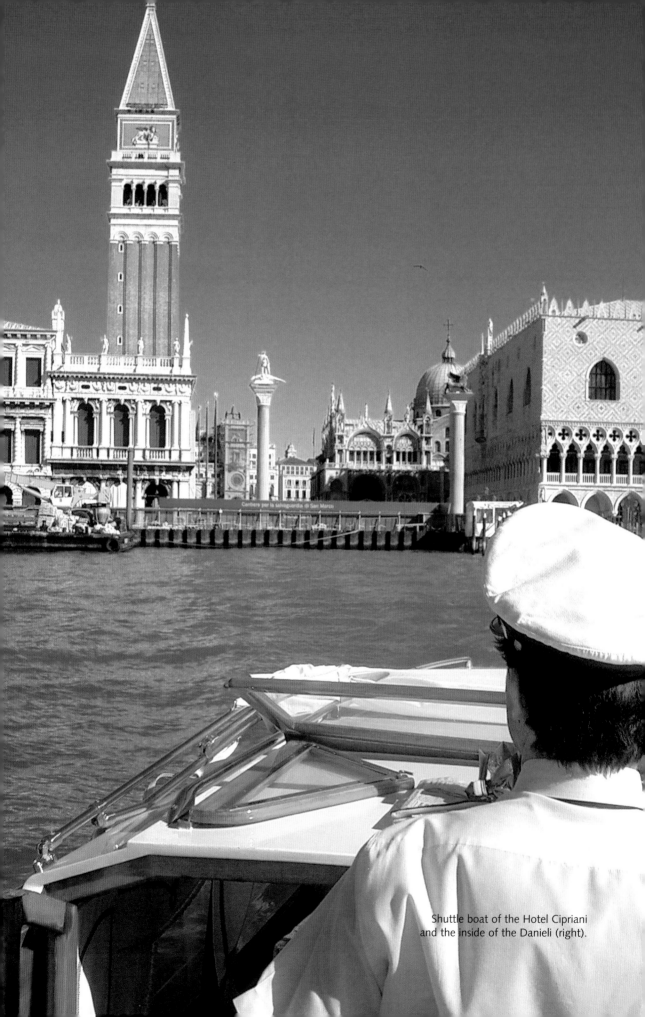

Shuttle boat of the Hotel Cipriani
and the inside of the Danieli (right).

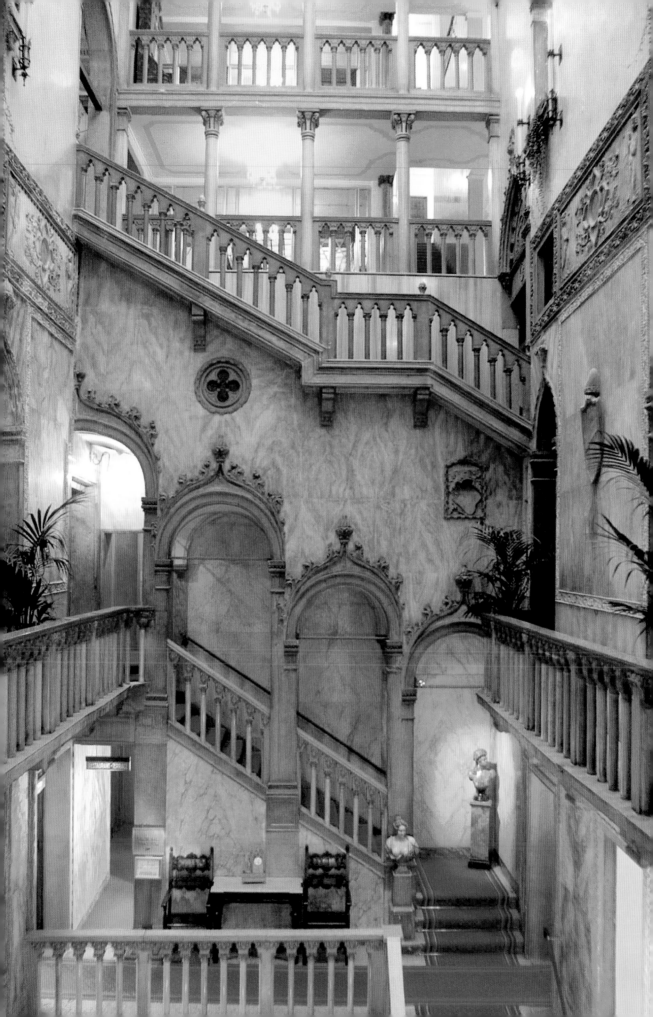

decoration. Its staff is exceptionally warm and welcoming, and the view over the Church of the Salute is sublime. On the other hand, it is really not the place to go for lunch or dinner. The "in" hotel restaurant for that, hands down, is the Monaco. Directly opposite Harry's Bar, it's where the in-the-know come for lunch and dinner. And though many criticize its small guest rooms, the service is exemplary, and its terrace overlooking the Dogana and the Salute has always been the place to be seen. Here the truly grand gather: stars of the Bienalle, actors, social figures, politicians, Venice's marquises and counts, French couturiers, English dukes, *tout le monde*. Despite the crowds, faithful customers are always shoehorned in and greeted like close family. Recently, the Monaco was expanded and refurbished by Benetton, and now unfortunately, it looks more Milanese modern than Venetian. On the other hand, it now includes the most beautiful *ridotto* in Venice, which has become a fabulous dining room.

For those who don't know the difference, the Danieli may seem the most spectacular hotel, but it suffers from being too large, with an enormous, Fascist-looking annex, and a nineteenth-century-inspired enclosed central courtyard in the style of a movie palace. The terrace of the annex is, however, a splendid place to see

The Hotel Gritti Palace, 2003.

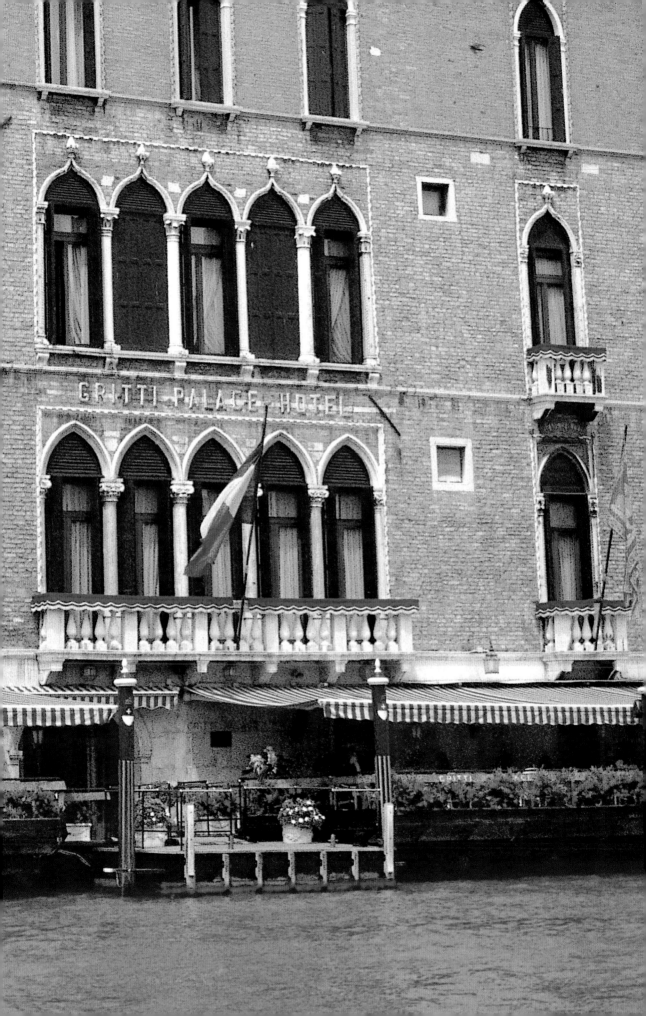

all of Venice while dining. The Danieli is "out" for dining and largely filled with an ordinary but rich clientele. This is probably the only grand hotel where the staff can forget everyone's names.

Also "in" during the summer season is the Cipriani, which offers an escape from Venice's heat and crowds with its enormous pool where people who all own even larger pools gossip and float around. Every day of the summer, there are large lunch parties where guests enjoy Bellinis and a buffet heavy on mozzarella, prosciutto, and cold Veneto wines. It costs a fortune just to have a swim, and every chic Venetian has a special deal or a way of cheating or getting in for free. The hotel was built by members of the Guinness family and now belongs to the container king James Sherwood, who collects exquisite trophy hotels like others collect impressionist paintings. Sherwood has also brought back the Orient Express and has created clones of it from Burma to the Andes.

It must also be said that no one's better looking than the handsome, dark-skinned, and invariably jet-black-haired bellboys of the Venetian grand hotels in their summer whites (von Aschenbach would come back today for that alone, leaving the effete Tadzio in a wading pool on the Lido), and no one is more helpful, supportive or better informed than a grand hotel's black-liveried and tailcoated porter or concierge. And what could be more romantic than having a late breakfast in bed, under crisp linen sheets, in near freezing, dead-silent air conditioning as the sun beats down on the green ripples below that shoot their sharp light onto soft, thin, muslin curtains of a paneled Gritti hotel room. There's hardly time for a heartbeat or the bite of a soft, warm peach before someone presses a button to bring down the shutters and both parties go back to their favorite occupation. It's no wonder Europeans head to Venice for honeymoons and secret trysts.

On the other side of the coin are dreary, slum hotels with cell-like airless rooms, where the management is rude and gouging, well-knowing that the poor louts who have schlepped their heavy suitcases from the train station or charter flights will never be back and hardly deserve their attention. By and large, Venetians have a totally cynical, ruthless attitude toward those that give them their livelihood; such is the aura of this magic place that thrives on the supposition that there will always be new gluttons for punishment. Venice is definitely a place where it's worth selling your last shirt to be rich.

A Venetian taxi, 1968.

66Who could have foretold
that Venice, where I passed through
as a mere traveler, and from which
I expected neither giving
nor receiving—if only a few artistic
impressions—would take hold of me,
of my self, of my passions.**99**

GEORGE SAND, *writing to Alfred de Musset from Venice.*

The Ca' d'Oro.

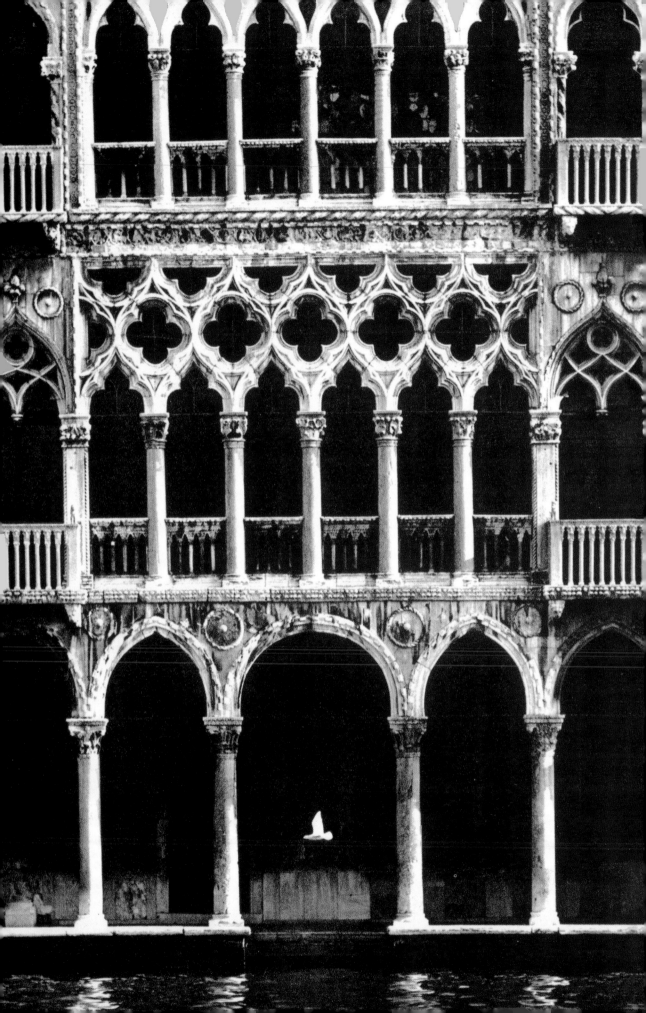

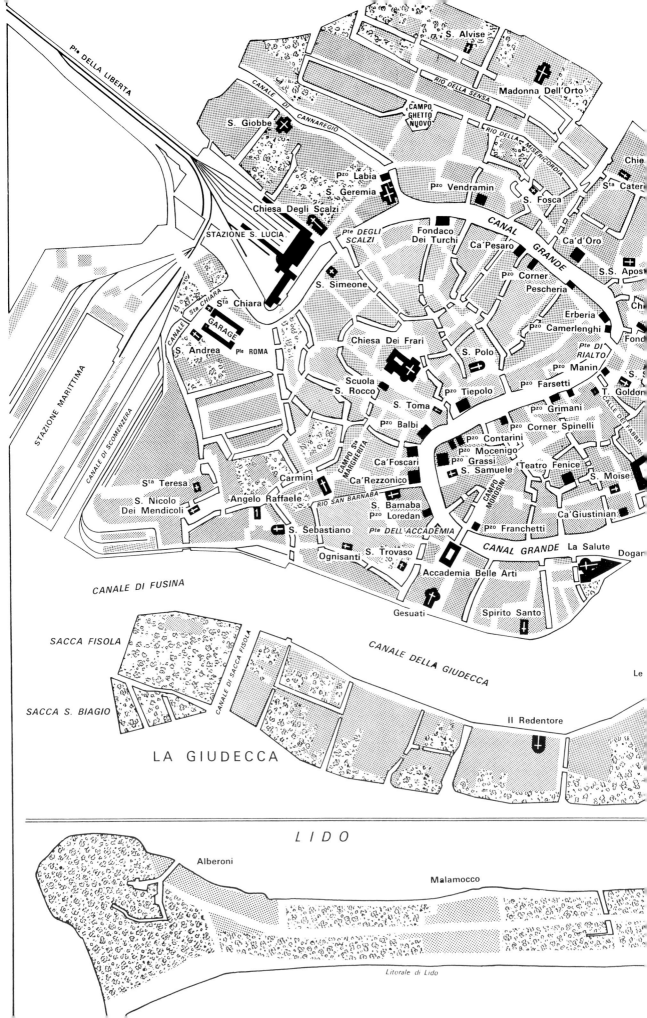

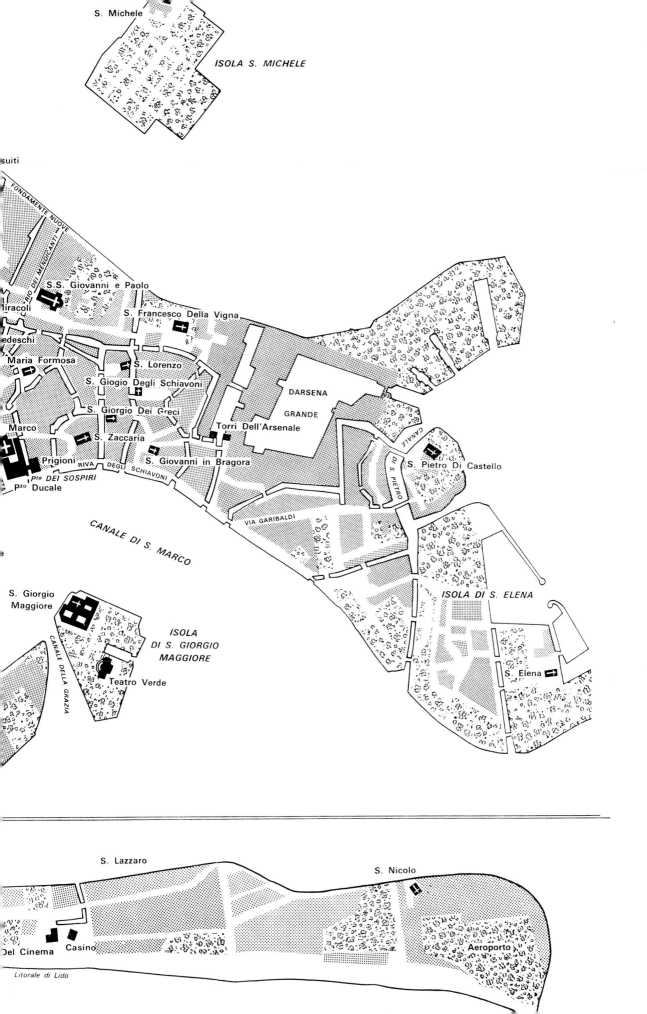

Bust of Jupiter, also known as the Zulian Sardonyx cameo. Hellenistic art,
Archeological Museum, Venice.

Other Treasures of Venice

Many important monuments are not discussed—or even mentioned—in this book. In case you are interested in more than having a good time in Venice, I would highly recommend that the following be visited, listed in alphabetical order so that they may easily be looked up in guidebooks or read about elsewhere.

Arsenale: Near the Giardini Publici is this fascinating ensemble of buildings that evoke the maritime life of the Venetian Republic. Its harbor is where the great galleys that conquered the East were made, and its museum is filled with remarkable displays.

Ca' Pesaro: Near the Rialto, this magnificent baroque palace by Baldassare Longhena and Antonio Gaspari houses very good museums of modern and Oriental art.

Ca' Rezzonico: Along with the still private Palazzo Albrizzi, this is the most beautiful and sumptuous 18th century palace in Venice. It has been splendidly restored and fully communicates the sumptuousness of Venetian life in the glory days of the Republic. It houses wonderful paintings and frescoes by Giam Battista and Domenico Tiepolo, a great many fascinating glimpses of Venetian life by Pietro Longhi, and some of the most beautiful and rare examples of carved and lacquered Venetian furniture still in existence. It once belonged to Robert Browning, and is also a jet-set monument thanks to Cole Porter, who often rented it and brought Elsa Maxwell along as his *maîtresse de plaisir*.

Fondaco dei Turchi: One of the oldest buildings in Venice dating from Byzantine times, it was the center for Turkish traders, hence its name. It presently contains a museum of natural history, and is interesting if your mind, while in Venice, is fixed on dinosaurs and other fauna, not to speak of Adriatic flora.

Galleria dell'Accademia: This comparatively little-visited museum devoted to Venetian masters is a treasure-house of masterpieces and must be spoken of with the same respect as that reserved for the Louvre, the Hermitage or the Metropolitan Museum of Art. The Accademia is the key to understanding Titian, the Bellinis, Giorgione, Tintoretto, Carpaccio, Guardi, and so many other towering figures of art history. The holdings are so rigorously edited that the Accademia, although a relatively small museum, is worth dozens of visits and is an essential pilgrimage for every art lover.

Gesuati or Santa Maria des Rosario: A very fine neoclassic church, reminiscent of the work of Andrea Palladio. It is very rich in the work of Gian Battista Tiepolo, Sebastiano Ricci, and Giovani Batista Piazetta.

Gesuiti or Santa Maria Assunta: A church with a truly extravagant sculpture-filled Roman Baroque facade and a particularly rich interior of green and white marble with wonderful pillars and colonnades. The church contains Titian's splendid *Martyrdom of St. Lawrence,* and was created, as its name would suggest, for the Jesuit order.

I Frari (also known as Santa Maria Gloriosa dei Frari): This large, red-brick and somewhat sober Renaissance church houses fascinating sculpted tombs of such leading artistic figures as Antonio Canova and Claudio Monteverdi, as well as two of Titian's most important altarpieces; the large *Assumption of the Virgin* and the smaller *Pesaro Altarpiece.* Also tucked into a small chapel is a staggering effigy of John the Baptist by Donatello.

Museo Archeologico: On the Piazza San Marco, one wing of the Procurator's Palace houses a large collection of Greek and Roman antiquities given by the ducal Grimani family.

Museo Civico Correr: Located in the Napoleonic wing of the Piazza San Marco, this museum is devoted to the cultural history of Venice and houses an excellent choice of Venetian painting, sculpture and decorative arts. There are also many fine statues by Canova.

Museum of Byzantine Icons. Just over a bridge from the Piazza San Marco, this small museum is a secret treasure, thanks to its remarkable collection of Byzantine icons that came primarily from Constantinople.

Palazzo Querini Stampaglia: This lovely Renaissance palace contains an important library, with 120,000 books mostly on subjects related to Venice and a fine picture gallery.

Rialto markets: Looking onto the famous bridge and stretching from the Grand Canal to enclose a large area of the Rialto quarter, this is a delightful way to glimpse everyday Venetian life. Stands overflow with luscious fruits and vegetables, glistening Adriatic fish and crustaceans (some so fresh that they are still wiggling), and any other imaginable produce of land and sea.

Santa Maria Formosa: A very fine church on a picturesque square that is occupied every morning by a fruit and vegetable market. Its Renaissance interior is absolutely charming, and it has fine altarpieces by Bartolomeo Vivarini and Palma Vecchio.

Santa Maria dei Miracoli: Recently restored and nestled between two branches of a small canal, this exquisite church by the sculptor/architect Pietro Lombardo is essentially a highly imaginative composition in multicolored marble, rather like a splendid jewel box. Its purity and elegance are the quintessence of the early Italian Renaissance.

Santi Giovanni e Paolo: Near the Piazza San Marco, this compendium of Gothic and Renaissance buildings is filled with great Renaissance sculpture by the likes of Antonio, Pietro, and Tullio Lombardo, and Alessandro Vittoria, a wonderful series of ceiling paintings by Veronese and Piazzetta, an altarpiece by Giovanni Bellini, and much, much more. Outside, on one flank of the church, is the iconic portrait of the Condottiere Bartolomeo Colleoni by Andrea del Verrochio, inspired by Donatello's Gattamelata statue outside the Santo cathedral in nearby Padua. These are the two finest equestrian portraits ever made. The church's facade flanks that of the Scuola Grande di San Marco (today Venice's main hospital), which is entirely covered by a gigantic stone neoclassical composition by the Lombardi brothers.

San Zaccaria: An important late-Gothic, early-Renaissance church that contains a splendid altarpiece by Giovanni Bellini and frescoes by the Florentine Andrea de Castagno.

Scuole Grandi: There were several Scuole (literally schools) in Venice. These were essentially meeting places and prayer centers for charitable confraternities. Their members were extremely rich and could indulge in commissioning major architects and artists for their scuola's construction and decoration.

The **Scuola Grande dei Carmini** contains one of the great ensembles of Giam Battista Tiepolo, in the form of nine ceiling paintings, including his most mature work, *Mary Handing St. Simon the Scapular of the Carmelites*, and the church's rococo paneling is a sheer delight.

The **Scuola Grande di San Rocco** is a High Renaissance building that is as important to understanding Tintoretto as the Sistine ceiling is to the oeuvre of Michelangelo. The walls and ceilings of the large and high first and second floors of this amazing building are literally covered with dozens of large panels on oil by this great master of Venetian painting. There are major works by other artists, including *A Kiss of Judas*, which is probably a collaboration between Titian and Giorgione, but so overwhelming is the effect made by Tintoretto himself that we are here only to worship at his altar.

And there is the enchanting **Scuola di San Giorgio degli Schiavone** whose walls are filled with panels concerning the life of St. George by that great storyteller Vittorio Carpaccio (1502–1508). These early works, made eighty years before the Tintorettos are of a touching simplicity that immediately puts every viewer into a happier and more innocent frame of mind.

Finally, there is the **Scuola San Giovanni Evangelista**, near the Frari, which announces itself with one of the most beautifully designed and carved Renaissance gates in all of Italy.

Walks: All of Venice is a museum, and walking through its many small streets is an essential experience for the enjoyment of the city. It is more likely that you will get terribly lost, but that is part of the fun. The city is really quite small and everybody finds their way home eventually. If you speak a bit of Italian, you can ask the friendly locals how to find a destination, but the city is such a labyrinth that you can never really follow what you have heard. It's all part of the experience.

AND ALSO...

Angelo San Raffaele (church): organ chest by Guarda.

Archivio di Stato (archives): one of the biggest archives in the world, housed in a former Franciscan convent.

Biblioteca Nazionale Marciana (library): the biggest collection of books about Venice, inside a building by Sansovino.

Ca' Vendramin Calergi (palace): Richard Wagner died here. It is presently the winter casino.

Campo San Bartolomeo (square): Goldoni's statue.

Campo San Polo (square): romantic little square worthy of Casanova.

Campo San Staè (square): one of the squares described in *Sherlock Holmes in Venice* by I. Lombardo.

Carmini (church): *Adoration of the Shepards,* by Cima, and one of the rare works of Lorenzo Lotto in Venice.

Convento di San Francesco del Deserto (convent): important Franciscan convent located on Burano.

Fondazione Querini Stampalia (library and museum): residence-museum of the Querini-Stampalia family (archives and objects from the 16th century), concerts, exhibitions.

Madonna dell'Orto (church): Saint John the Baptist by Cima; altar painting by Giovanni Bellini; *Presentation of the Virgin* by Tintoretto; and *The Golden Calf* by the same artist. Tintoretto's ashes are here.

Monastero Mekhitarista (monastery): library and collection of works and documents about Armenian history.

Museo Ebraico: objects and works relating to the social and religious life of the Jewish community, gathered in two 16th century synagogues.

Museo dell'Estuario: collection of Greco-Roman antiquities gathered in the estuary and dated from the Palae-Venetians and from the Etruscans.

Museo Diocesano di Arte Sacra: religious furniture and objects gathered from present day churches and convents; just beside, one of the most romantic cloisters of the city.

Museo Vetrario: history of Venetian glass over the centuries.

Oratorio dei Crociferi: little chapel in front of the former convent of the same name; series of paintings by Palma di Giovane.

Palazzo Labia (palace): decorated by Tiepolo; the most sumptuous ball of the postwar period took place there in 1951. It is now headquarters of the RAI.

Palazzo Mocenigo (museum and library): residence-museum of the Mocenigo family (18th-century interiors); a lady in love with Lord Byron threw herself into the canal from one of the balconies.

San Cassiano (church): *Deposition* by Titian. San Francesco della Vigna (cloister): a Madonna by Negroponte.

San Giacomo dell' Orio (church): a marble column from Greece; a wooden ceiling in the shape of a boat hull; its big blue clock featuring a 24-hour dial appears in a well-known painting by Canaletto.

San Giobbé (church): grave of the "true Othello," the doge Cristoforo Moro.

San Giorgio Maggiore (church): white, fresh, and austerely religious building by Palladio; works of art by Jacopo da Bassano, Sebastiano Ricci, Tintoretto and Carpaccio; from the top of the bell tower, incomparable view of Venice.

San Giovanni Grisostomo (church): altarpiece by Giovanni Bellini, which is his last work.

San Giovanni in Bragora (church): large painting by Cima.

San Pietro di Castello (church): throne used by Saint Peter in Antioch.

San Sebastiano (church): decorated by Veronese, who is buried here.

Sant' Alvise (church): *Ascent to Calvary* by Giam Battista Tiepolo.

Sant' Elena (church): representation of a supplicant by Antonio Rizzo.

Santo Stefano (church): Doge Francesco Morosini (1616–1694) is buried under paving stones.

Scalzi, or Santa Maria di Nazareth (church): grave of the last doge, Ludovico Manin.

Scuola Dalmata di San Giorgio degli Schiavoni (museum): works by Carpaccio depicting the lives of Saint George, Saint Tryphon and Saint Jerome.

Scuola di Merletti (museum): collection of antique lace.

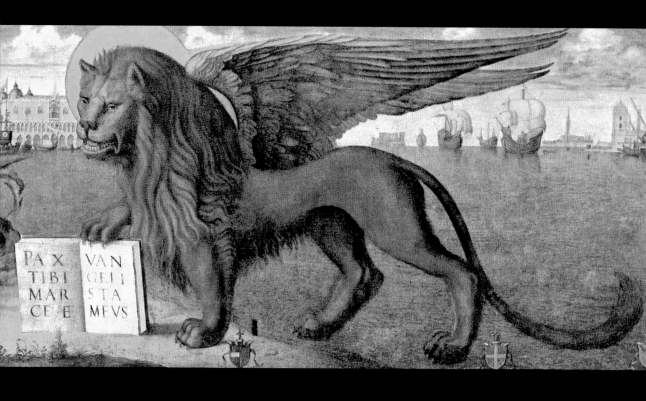

The text in the painting reads:

PAX TIBI MAR CE E — VAN GELI STA MEVS

The Lion of Saint Mark, Vittore Carpaccio, 1516, oil on canvas, 42$^{1/5}$ x 21$^{3/5}$", Ducal Palace, Venice.

Addresses in Venice

BARS & CLUBS

Café Florian - Piazza San Marco
Tel.: 041 520 56 41; caffeflorian.com

Gran Café Quardri - Piazza San Marco
Tel.: 041 522 21 05

Gelateria Nico - Zattere ai Gesuati 922
Tel.: 041 522 52 93; gelaterianico.com

Linea d'Ombra - Zattere ai Saloni 19
Tel.: 041 241 18 81;

ristorantelineadombra.com

Enoteca Mascareta - Calle Lunga S.M.
Formoso Castello 5225

Tel.: 041 523 07 44

Ristorante Masaniello - Campo San Stefano
2801 - Tel.: 041 520 90 03

BASILICAS

Frari - Campo dei Frari - San Polo
Tel.: 041 272 86 11

San Marco - Piazza San Marco
Tel.: 041 270 83 11

Santa Maria Assunta di Torcello - Torcello
Tel.: 041 73 01 19

Santos Maria e Donato - Campo San Donato,
Isola di Murano - Tel.: 041 523 03 99

CHURCHES

Angelo Raffaele
Campo dell'Anzolo Rafael 1721

Carmini - Dorsoduro 2617
Tel.: 041 522 65 53

Gesuati (or Santa Maria del Rosario)
Zattere, Dorsoduro - Tel.: 041 275 04 62

Gesuiti (or Santa Maria Assunta)
Salizada de la Spechiera 4885

Madonna dell'Orto - Cannareggio 3512
Tel.: 041 71 99 33

Monastero Mekhitarista - Isola San Lazzaro
degli Armeni - Tel.: 041 526 01 04

Oratorio dei Crociferi - Campo dei Gesuiti
Cannaregio 4905 - Tel.: 041 521 74 11

Ospedaletto - Barbarie dello Tole 6691
Tel.: 041 132 4933

Redentore - Giudecca 195
Tel.: 041 523 14 15

San Bartolomeo - Campo San Bartolomeo
San Marco 5346 - Tel.: 041 270 24 64

San Cassiano - Campo San Cassan 1852
Tel.: 041 524 17 68

San Francesco del Deserto
San Francesco del Deserto - Tel.: 041 528 68 63

San Francesco della Vigna - Campo San
Francesco della Vigna - Tel.: 041 523 53 41

San Giacomo dell' Orio - Campo Giacomo
dell' Orio 1456 - Tel.: 041 275 04 62

San Giobbé - Campo San Giobbe 620
Tel.: 041 524 18 89

San Giorgio Maggiore - Isola di San Giorgio
Maggiore, Giudecca - Tel.: 041 522 78 27

San Giovanni Crisostomo -
Salizada San Giovanni Crisostomo 5889
Tel.: 041 523 52 93

San Giovanni in Bragora - Campo Bandiera
e Moro - Tel.: 041 520 59 06

San Pietro di Castello - Campo San Pietro
70 - Tel.: 041 275 04 62

San Sebastiano - Campo San Sebastiano
1686 - Tel.: 041 275 04 62

San Zaccaria - Campo San Zaccaria 4693
Tel.: 041 522 12 57

San Zanipolo (or Santos Giovanni e Paolo)
Campo Santos Giovanni e Paolo 6363 -
Tel.: 041 523 59 13

Sant' Alvise - Campo Sant' Alvise
Tel.: 041 275 04 62

Sant' Elena - Campo della Chiesa Sant' Elena

Santa Maria dei Miracoli - Campiello dei
Miracoli 6075 - Tel.: 041 275 04 62

Santa Maria della Salute - Campo della
Salute 1 - Tel.: 041 241 10 18

Santa Maria Formosa - Campo Santa Maria
Formosa 5263 - Tel.: 041 523 46 45

Santo Stefano - Campo Santo Stefano 2774
Tel.: 041 522 23 62

Scalzi (or Santa Maria di Nazareth)
Fondamenta degli Scalzi 57

HOTELS IN VENICE

5 stars

Bauer Grünwald - Campo San Moisè 1459
Tel.: 041 520 70 22; bauervenezia.com

Boscolo Venezia - Fond.ta Madonna
dell'Orto, 3500 - Tel.: 041 220 81 11;
boscolohotels.com

Cipriani - Giudecca 10 - Tel.: 041 520 77 44;
hotelcipriani.com

Danieli - Riva degli Schiavoni 4196
Tel.: 041 522 64 80; danielihotelvenice.com

Gritti Palace - San Marco 2467
Tel.: 041 79 46 11; thegrittipalace.com

Westin Europa e Regina - Calle Larga XXII
Marzo 2159 - Tel.: 041 240 00 01;
westineuroparegavenice.com

4 stars
B4 Bellini Venezia - Lista di Spagna 116
Tel.: 041 524 24 88;
boscolobellini.hotelinvenice.com

Hotel Colombina - Castello 4416
Tel.: 041 277 05 25; hotelcolombina.com

Londra Palace - Riva degli Schiavoni 4171
Tel.: 041 520 05 33; londrapalace.com

Metropole - Riva degli Schiavoni 4149
Tel.: 041 520 50 44; hotelmetropole.com

Monaco & Grand Canal - Calle Vallaresso
1325 - Tel.: 041 520 02 11; hotelmonaco.it

Principe - Lista di Spagna 146
Tel.: 041 220 40 00; hotelprincipevenice.it

3 stars
Ambassador Tre Rose - San Marco 905
Tel.: 041 522 24 90; hotelambassador-
venice.com

Bel Sito - Santa Maria del Giglio 2517
Tel.: 041 522 33 65; hotelbelsitovenezia.it

Belle Arti - Dorsoduro 912
Tel.: 041 522 62 30; hotelbellearti.com

Casanova - Frezzeria 1284
Tel.: 041 520 68 55; hotelcasanova.it

Hotel American Dinesen - San Vio 628 -
Tel.: 041 520 47 33; hotelamerican.com

La Fenice et des Artistes - Campiello della
Fenice - Tel.: 041 523 23 33;
fenicehotels.com

Locanda Cipriani - Torcello 29
Tel.: 041 73 01 50; locandacipriani.com

Malibran - Cannaregio 5864
Tel.: 041 522 80 28; hotelmalibran.com

Marconi - San Polo Riva del Vin 729
Tel.: 041 522 20 68; hotelmarconi.it

Olimpia - P.le Roma 395/6
Tel.: 041 71 10 41; hotel-olimpia.com

Pensione Accademia - Dorsoduro 1058
Tel.: 041 521 01 88; pensioneaccademia.it

Santo Stefano - Campo Santo Stefano 2957
Tel.: 041 520 01 66;
hotelsantostefanovenezia.com

2 stars
Agli Alboretti - Dorsoduro 884 - Accademia
Tel.: 041 52 300 58; aglialboretti.com

Campiello - Castello 4647
Tel.: 041 52 057 64; hcampiello.it

Canaletto - Castello - San Liso 5487
Tel.: 041 522 05 18; hotelcanaletto.com

Casa Fontana - Campo San Zaccaria 4701
Tel.: 041 522 05 79; hotelfontana.it

La Residenza - Castello 3608
Tel.: 041 528 53 15; venicelaresidenza.com

Leonardo - Cannaregio 1385
Tel.: 041 71 86 66; hotelleonardo.com

Pensione Seguso - Zattere 779
Tel.: 041 528 68 58;
pensionesegusovenice.com

Pensione Wildner - Riva Schiavoni 4161
Tel.: 041 522 74 63; hotelwildner.com

Tivoli - Dorsoduro 3838
Tel.: 041 524 24 60; hoteltivoli.it

HOTELS ON THE LIDO
5 stars
Excelsior - Lung. Marconi 41
Tel.: 041 526 02 01;
hotelexcelsiorvenezia.com

4 stars
Biasutti - Via E. Dandolo 27/29
Tel.: 041 526 01 20; biasuttihotels.com/it

Golf Residence - Malamocco
Tel.: 041 526 95 12

Grand Hotel des Bains - Lung. Marconi 17
Tel.: 041 260 23 09; des-bains.com

Le Boulevard - Gran Viale S.M. Elisabetta 41
Tel.: 041 526 19 90; leboulevard.com

Quattro Fontane - Via Quattro Fontane 16
Tel.: 041 526 02 27; quattrofontane.com/en

Villa Laguna - P.le S.M. Elisabetta
Tel.: 041 526 13 16

Villa Mabapa - Riviera San Nicolò 16
Tel.: 041 526 05 90; villamabapa.com

3 stars
Belvedere - P.le S.M. Elisabetta 4
Tel.: 041 526 01 15; belvedere-venezia.com

Byron Hotel - Via M. Bragadin 30
Tel.: 041 526 00 52; byron-hotel.com

Petit Palais - Lungomare Marconi 54
Tel.: 041 526 40 30; hotelpetitpalais.eu

Riviera - Gran Viale 5 - Tel.: 041 526 00 31;
rivieravenezia.it

Villa Tiziana - Via Andrea Gritti 3
Tel.: 041 526 11 52; hotelvillatiziana.net

2 stars

Rivamare - Lungomare G. Marconi 44
Tel.: 041 526 03 52; hotelrivamare.com

Villa Aurora - Riviera San Nicolò 11
Tel.: 041 526 05 19; hotelaurora.com

LIBRARIES & CULTURAL CENTERS

Ateneo San Basso - Piazza San Marco
Tel.: 041 521 02 94

Biblioteca Nazionale Marciana - Piazzetta
San Marco 13/a - Tel.: 041 520 87 88

Centro Cultural delle Zitelle - Isola della
Giudecca - Tel.: 041 714 066

Cinema Giorgione - Cannaregio 4612
Tel.: 041 522 62 98

MUSEUMS

Archivio di Stato - Frari - San Polo 3002
Tel.: 041 522 22 81

Ca' d'Oro (or Galleria Franchetti)
Calle di Ca' d'Oro 3932 - Tel.: 041 523 87
90; cadoro.org

Ca' Pesaro (or Galleria d'Arte Moderna)
Santa Croce 2076 - Tel.: 041 72 11 27;
capesaro.visitmuve.it

Ca' Rezzonico (or Museo del '700
Veneziano) - Dorsoduro 701 - Tel.: 041 241
01 00; carezzonico.visitmuve.it

Ca' Vendramin Calergi - Cannaregio
Tel.: 041 529 72 30

Collezione Peggy Guggenheim
Dorsoduro 701 - Tel.: 041 240 54 11;
guggenheim-venice.it

Fondaco dei Turchi - Santa Croce 1730
Tel.: 041 275 91 77

Fondazione Querini Stampalia - Campo S.
Maria Formosa - Castello 4778 Tel.: 041
271 14 11; querinistampalia.it

Gallerie dell'Accademia - Accademia,
Dorsoduro - Tel.: 041 520 03 45; gallerieac-
cademia.org

Museo Archeologico - Piazza San Marco 52
Tel.: 041 522 59 78;
polomuseale.venezia.beniculturali.it

Museo Ebraico - Cannaregio 2902/b - Tel.:
041 71 53 59; museoebraico.it

Museo Correr - Ala napoleonica - Piazza
San Marco - Tel.: 041 240 52 11; correr.vis-
itmuve.it

Museo dell'Estuario - Palazzo del Consiglio
Tel.: 041 73 07 61

Museo Diocesano di Arte Sacra - Centro
d'Arte di S'Apollonia - Ponte della Canonica
Tel.: 041 522 91 66

Museo Dipinti Sacri Bizantini - Ponte dei Greci
Castello 3412 - Tel.: 041 522 65 81

Museo Orientale - Ca' Pesaro
Tel.: 041 524 11 73; arteorientale.org

Museo Storico Navale
Ex Granai della Repubblica - Arsenal
Castello 2148 - Tel.: 041 244 13 29

Museo Vetrario - Fondamenta Giustinian 8
Tel.: 041 73 95 86; museovetro.visitmuve.it
Palazzo Albrizzi - Cannaregio 4118
Tel.: 041 52 32 544

Palazzo Cini - San Vio – Accademia
Dorsoduro 864 - Tel.: 041 521 07 55; cini.it

Palazzo Ducale - Piazzetta San Marco
Tel.: 041 271 59 11; palazzoducale.visit-
muve.it

Palazzo Fortuny - Campo San Beneto
San Marco 3958 - Tel.: 041 520 09 95;
fortuny.visitmuve.it

Palazzo Grassi - San Samuele 3231
Tel.: 041 523 16 80; www.palazzograssi.it

Palazzo Labia - Santa Geremia
Cannaregio - Tel.: 041 524 28 12

Palazzo Mocenigo - San Stae 1992
Tel.: 041 72 17 98; mocenigo.visitmuve.it

Palazzo Pisani - Campiello Pisani
Tel.: 041 520 52 27

Scuola Dalmata di San Giorgio degli Schiavoni -
Ponte dei Greci - Castello - Tel.: 041 522 88 28

Scuola di Merletti - Piazza Galuppi
Tel.: 041 73 00 34; museomerletto.visit-
muve.it

Scuola di San Giorgio dei Schiavoni
Castello 3259/a - Tel.: 041 522 88 28

Scuola Grande dei Carmini
Dorsoduro 2617 - Tel.: 041 528 94 20

Scuola Grande di San Giovanni Evangelista
Calle de la Laca 2454 - Tel.: 041 718 234;
scuolasangiovanni.it

Scuola Grande di San Rocco
San Polo 3052 - Tel.: 041 523 48 64;
scuolagrandesanrocco.it

RESTAURANTS

Antico Martini - San Marco 1983
Tel.: 041 522 41 21; anticomartini.com/en

Ca' dei Frati - Isola di San Clemente 1
Tel.: 041 244 50 01; san-
clementepalacevenice.com

Cip's Club - Fondamenta delle Zitelle 10
Tel.: 041 520 77 44

Corte Sconta - Calle del Pestrin,
3886 - Tel.: 041 522 70 24

Da Ivano - Piazzale Roma 295
Tel.: 041 524 66 48; da ivanovenezia.it

Da Ivo - Calle dei Fuseri 1809
Tel.: 041 528 50 04; ristorantedaivo.com

Do Forni - San Marco 468
Tel.: 041 523 21 48; doforni.it

Do Leoni - Riva degli Schiavoni 4171
Tel.: 041 520 05 33

Harry's Bar - Calle Vallaresso 1323
Tel.: 041 528 57 77; harrysbarvenezia.com

Harry's Dolci - Fondamenta San Biagio 773
Tel.: 041 522 48 44

Osteria ai 4 Feri - Calle Lunga San Barnaba,
2754/a - Tel.: 041 520 69 78

Trattoria alla Madonna - Calle della Madonna
594 - Tel.: 041 522 38 24

Taverna La Fenice - Campiello de la Fenice
1939 - Tel. : 041 522 38 56; ristorantelafenice.it

Zucca - Santa Croce 1762
Tel.: 041 524 15 70; lazucca.it

SHOPPING

Antichità Santomanco (antiques)- San Marco
1567 - Tel.: 041 523 66 43

Ars Cenedese Murano (glass) - Piazza San Marco
40-41 - Tel.: 041 522 54 87; arscenedese.com

Basso, Gianni (books) - Calle del Fumo 5306
Tel.: 041 523 46 81

Buccellati (jeweler) - Merceria Orologio
Tel.: 041 522 65 40; buccellati.com

Cam (glass) - Piazzale Colonna 1/b
Tel.: 041 73 99 44

Cantiere Motonautico Serenella (boats) Sacca
Serenella (glass) - Tel.: 041 73 97 92

Codognato (jeweler) - Calle Seconda de l'Ascension
1295 - Tel.: 041 522 50 42; attiliocodognato.it

Dolce & Gabbana (fashion)
San Marco 223-6 - Tel.: 041 520 99 91

Fendi (fashion) - San Marco 1474
Tel.: 041 277 85 32

Flavia (costumes) - Campo San Lio 5630
Tel.: 041 241 3200; veniceatelier.com

Frette (linens) - Calle Larga XXII Marzo 2070/a
Tel.: 041 522 49 14

Grafica Antica (antiques) - Calle Larga XXII Marzo
2089 - Tel.: 041 522 71 99

Gucci (fashion) - San Marco 258 - Tel.: 041 522 91 19

Jesurum (linens) - Calle Larga 22 Marzo, San Marco
2401 - Tel.: 041 523 89 69; jesurum.it

Laboratorio Artigiano Maschere (masks) Barbaria
della Tolle 6656 - Tel.: 041 522 31 10

Mazzega (glass) - Fondamenta da Mula 147
Tel.: 041 73 68 88

Missoni (fashion) - Calle Vallaresso 1312
Tel.: 041 520 57 33

Nardi (jeweler) - Piazza San Marco 69
Tel.: 041 522 57 33; nardi-venezia.com

Salvadori (jeweler) - Mercrerie San Salvador
5022 - Tel.: 041 520 08 99

Venetia Studium (Fortuny products)
San Marco 2425 - Tel.: 041 523 69 53

Versace (fashion) - Campo San Moisè 1462
Tel.: 041 520 00 57

Vianello (jeweler) - Piazza San Marco 67
Tel.: 041 522 13 87

Vivarini (glass) - Fondamenta Serenella 5/6
Tel.: 041 73 60 77

THEATERS & CINEMAS

A l'Avogaria - Dorsoduro 1617 - Tel.: 041 520 92 70

Accademia - Dorsoduro 1018 - Tel.: 041 528 77 06

Astra - Via Corfù (Lido) - Tel.: 041 526 57 36

Corso - Mestre - Tel.: 041 97 26 15

Fondamente Nuove - Cannaregio 5013
Tel.: 041 522 44 98

La Fenice - San Marco 1965 - Tel.: 041 78 65 11

Giorgione Movie - Cannareggio 4612
Tel. : 041 522 62 98

Goldoni - San Marco 4650/B - Tel.: 041 240 20 11/14

Ritz - San Marco 617 - Tel.: 041 520 44 29

Rossini - San Marco 400 - Tel.: 041 523 03 22

Palazzo del Cinema - Lido - Tel.: 041 526 01 88

Teatro Malibran - Cannaregio - Tel.: 041 786 611

Tonolio - Piazzetta Cesare Battisti, Mestre
Tel.: 041 97 16 66

VENETIAN VILLAS

On the Brenta

Villa Foscari "La Malcontenta" - Tel. : 041 547 00
12; lamalcontenta.com

Barchessa Valmarana (Villa Widmann Foscari) Tel. : US:
310 428 4223; Italy: 041 426 6387; villavalmarana.com

Villa Pisani ora Nazionale - Stra - Tel. : 049 50 20 74

Villa Foscarini-Rossi - Stra - Tel. : 049 980 03 35

Treviso and Surroundings

Villa Barbaro - Maser - Tel. : 0423 92 30 04

Castello di Roncade - Tel. : 0422 70 87 36; castel-
lodironcade.it

Padua And Surroundings

Villa Contarini - Piazzola sul Brenta - Tel. : 049 559
02 38; hotelvillacontarininenzi.com

Villa Barbarigo Pizzoni Ad Valsanzibio - Tel. : 049
805 92 24; valsanzibiogiardino.it

USEFUL INFORMATION

Tourism Office - Calle Larga dell Ascensione
Tel.: 041 522 63 56; visit-venice-italy.com
Police - Tel.: 113
Ambulance - Tel.: 041 523 00 00 or 118
Marco Polo Airport - Tel.: 041 260 61 11
Airport Information - Tel.: 041 260 92 60
Airport lost & found - Tel.: 041 260 64 36
Fire Station - Tel.: 041 520 02 22 /25 74 700
Railway Information - Tel.: 848 88 088
Night Chemists Information
Tel.: 041 523 05 73
Venice City Hall - Tel.: 041 274 81 11
A.V.A ASS. Ven. Albergatori
Tel.: 041 522 80 04

VAPORETTO

Line 1 : "Accelerato" P. Roma - Ferrovia - Rialto - San Marco - Lido (back and forth).

Line N : Night Service Lido - Canal Grande - P.le Roma - Tronchetto - Canale Giudecca - San Zaccaria (back and forth).

Line 41 : San Zaccaria - Arsenale - Bacini - Celestia - Ospedale - F. Nuove - Cemetary - Murano - Cimitero - F. Nuove - Orto - S. Alvise - Tre Archi - Guglie - Ferrovia - P.le Roma - S. Marta - Sacca Fisola - S. Eufemia - Redentore - Zitelle - San Zaccaria.

Line 42 : Zitelle - Redentore - Sacca Fisola - S. Marta - P. Roma - Ferrovia - Guglie - Tre Archi - S. Alvise - Orto - Fondamenta Nuove - Cimitero - Murano - Cemetary - . Nuove - Ospedale - Celestia - Bacini - Zaccaria-Giardini.

Line 51 : Lido - S. Pietro - Bacini - Celestia - Ospedale - Fondamenta Nuove - S. Alvise - Tre Archi - Guglie - Ferrovia - P. Roma - S. Marta - Zattere - San Zaccaria - Giardini - S. Elena - Lido.

Line 52 : Lido - S. Elena - Giadini - San Zaccaria - Zattere - S. Marta - P. Roma - Ferrovia - Guglie - Tre Archi - S. Alvise - Orto - Fondamenta Nuove - Ospedale - Celestia - Bacini - S. Pietro - Lido.

Line 61 : Piazzale Roma - Zattere - Giardini - Sant'Elena - Lido.

Line 62 : Lido - S. Elena - Giardini - Zattere - Piazzale Roma.

Line 82 : San Zaccaria - S. Giorgio Giudecca - Zattere - Sacca Fisola - Tronchetto - P. Roma - Ferrovia - S. Marcuola - Rialto S. Marco - San Zaccaria - Lido (back and forth).

Line 6 - 12 - 14 : Lido - Punta Sabbioni - Treporti - Burano - Torcello- Burano - Mazzorbo - Murano - F. Nuove (back and forth).

Line 17 : Tronchetto - Lide (back and forth).

TRAGHETTI

Ferrovia	7:45 am - 1:45 pm
San Marcuola	7:30 am - 1:30 pm
Santa Sofia	7:20 am - 8:55 pm
al Carbon	8:00 am - 2:00 pm
San Toma	7:20 am - 8:55 pm
San Samuele	7:15 am - 1:15 pm
S. Maria del Giglio	8:00 am - 7:00 pm
Dogana	9:00 - 12:30 am & 2:00 - 6:00 pm

WATER-TAXI

Serenissima - Tel.: 041 522 12 65
Venezia Taxi - Tel.: 041 72 30 09
Marco Polo - Tel.: 041 96 61 70
Sotoriva - Tel.: 041 520 95 86
Radio Taxi - Tel.: 041 595 2080

GONDOLA STANDS

Bacino Orseolo - Tel.: 041 241 00 85
Danieli - Tel.: 041 522 22 54
Dogana - Tel.: 041 520 61 20
Ferrovia - Tel.: 041 71 85 43
Piazzale Roma - Tel.: 041 522 11 51
S. Maria del Giglio - Tel.: 041 522 20 73
San Marco - Tel.: 041 520 06 85
S. Sofia - Tel.: 041 522 28 44
Trinita - Tel.: 041 523 18 37

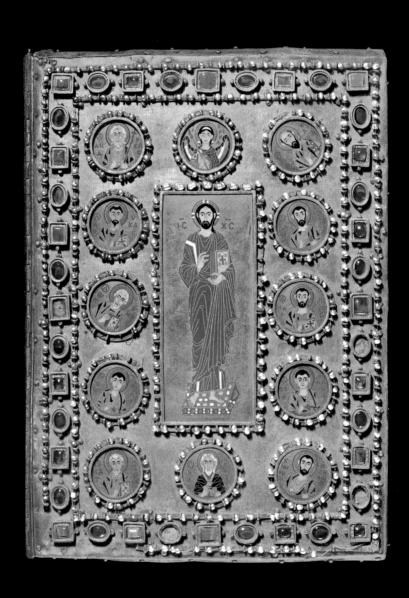

Cover of a Byzantine Gospel Book. Christ in enamel on gold ground, surrounded by enamel medallions of saints within a border of precious stones and pearls. Mid-10ᵗʰ century, Marciana Libary, Venice.

Bibliography

This book is part of a series published by Assouline on resorts and places of pleasure; other books in the series are devoted to Saint Tropez, Cannes, Aspen, the Hamptons, and the French Riviera. Consequently, I have written about Venice above all as a place for enjoyment by people of all ages. This should not be regarded as a guidebook to use as you go around the city, nor as a summation of Venetian culture, history, or civilization to be read in preparation of your first trip. It is sooner an evocation of the atmosphere of the city, of some of the main monuments, sites, and themes that interest visitors to this very special environment—art, architecture, restaurants, grand hotels , romance, glass, jewelry, life on the Lido, the Biennales of art and film,the grand palaces and grand people of the past. Among the main sources of my research—not the least of which is visiting Venice every year since 1958, with mainly pleasure in mind—are the following books, all of which I can highly recommend.

The Architectural History of Venice, Deborah Howard, Yale University Press, New Haven, 2002.
Baedeker's Venice, Karl Baedeker, Baedeker's, New York, 2000.
Codognato, Pierre Hebey, Assouline, New York, 2002.
The Companion Guide to Venice, Hugh Honour, Companion Guides, New York, 2001.
Dictionnaire amoureux de Venise, Philippe Sollers, Plon, Paris, 2004.
Fortuny, Delphine Desveaux, Assouline, collection "Mémoire de la mode", Paris, 2004.
Fortuny: The Life and Work of Mariano Fortuny, Guillermo de Osma, Rizzoli, New York, 1994.
The Grand Canal, Umberto Franzoi, Mark Smith, Daniel Wheeler, The Vendome Press, New York, 1993.
A History of Venice, John Julius Norwich, Vintage Books, New York, 1982.
Infinite Variety: The Life & Legend of the Marchesa Casati, The Definitive Edition, Scot D. Ryersson, Michael Orlando Yaccarino, University of Minnesota Press, Minneapolis, 2004.
Islands and Lagoons of Venice, Fulvio Roiter and Peter Lauritzen, The Vendome Press, New York, 1980.
Legendary Parties, Jean-Louis de Faucigny-Lucinge, The Vendome Press, New York, 1987.
Music's Modern Muse: A Life of Winnaretta Singer, Princesse de Polignac, Sylvia Kahan, University of Rochester Press, Rochester, 2003.
Palaces of Venice, Peter Lauritzen and Alexander Zielcke, Phaidon, London, 1978.
Peggy Guggenheim, Paolo Barozzi, Assouline Publishing, New York, 2005.
The Stones of Venice, Lionello Puppi, The Vendome Press, New York, 2002.
The Stones of Venice, John Ruskin, Little, Brown and Company, New York, 1981.
Treasures of Venice, Michelangelo Muraro and André Grabar, Rizzoli, New York, 1980.
The Venetian Ghetto, Roberta Curiel and Bernardo Cooperman, Rizzoli, New York, 1990.
The Venice Biennale 1865-1968: from salon to goldfish bowl, Lawrence Alloway, New York Graphic Society Ltd., New York, 1968.
Venice: Art and Architecture, Giandomenico Romanelli, Konemann, New York, 1997.
Venice Observed, Mary McCarthy, Harvest Books, New York, 1963 .
Venice Triumphant: The Horizons of a Myth, Elisabeth Crouzet-Pavan, Johns Hopkins University Press, Baltimore, 2002.
The World of Venice, Jan Morris, Harcourt Brace, New York, 1993.

Photo Credits

Acknowlegments

The Publisher wishes to thank Francesca Alongi, Marie-Odile Andrade (Foundation Singer Polignac), Giovanna Arcangeli (Harry's Bar), Italo Ballarin, François Baudot, Fernando Bertuzzi, Beatrice Campion (Magnus Edizioni Spa), Raphaelle Cartier and Jan Pierrick (RMN), Christelle (Picture Desk), Attilio Codognato, Serge Darmon (Christophe L), Francesca Ferretti (Contrasto), Véronique Garrigue (ADAGP), Cory Grace (Freer Gallery of Art), Helen Gordon-Smith (Condé Nast Publication Ltd), Ulrike Haussen and Hervé Mouriacoux (AKG), Patricia Lastier (Getty Images), Tito Magrini (Sotheby's), Barbara Mazza (Roger Viollet), Daniela Mericio and Anna Locatelli (Olycom/Publifoto), Alison Miles (Tate Picture Library), Patricia Mohamed (Agence Rea), Andrea Montagnani (VianelloLibri), Julie Papini and Isabelle Martin (Corbis), Svetlana Ramon-Pironko, Paola Renna (*Vogue* Italy), Laurence Scherrer, Scot & Michael (The Casati Archives), Catherine Terk (Rue des Archives), Susan Train and Iann Roland-Bourgade (Conde Nast Inc.), Michèle Zaquin and Caroline Berton (Condé Nast France).

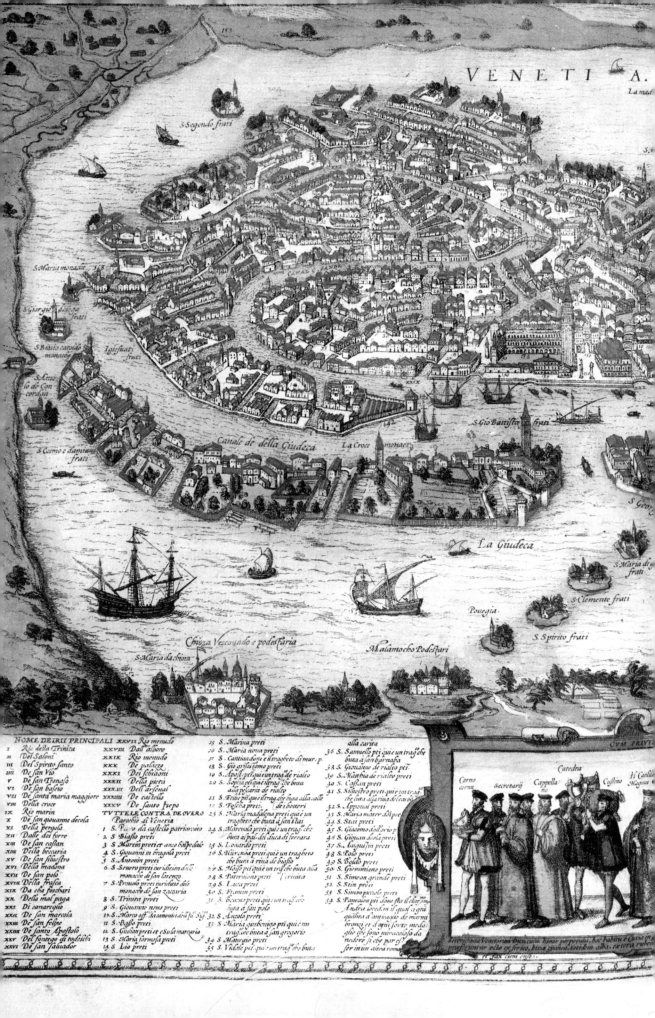